THE ILLUMINATED LIFE OF CHRIST

THE ILLUMINATED LIFE OF CHRIST

The Gospels and Great Master Paintings

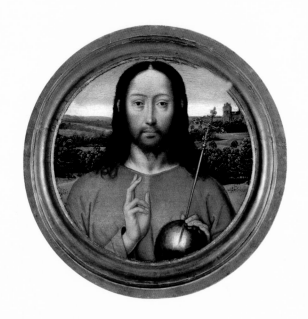

BLACK DOG
& LEVENTHAL
PUBLISHERS

Cover image: Hans Memling, detail of Salvator Mundi, 1475–99; © The Metropol-
itan Museum of Art, Image source: Art Resource.

Image credits: Pages 18, 64, 72, 88, and 205 courtesy of Alinari/Getty Images; page
86 courtesy of Art Images/Getty Images; pages 15, 16, 20–21, 23, 39, 45, 46, 48,
68, 83, 96, 106–107, 108, 110, 112, 126, 130, 146, 150, 152, 156, 166, 168–169,
170, 176, 178, 180, 188, 196, and 202 courtesy of DeAgostini/Getty Images; page
210 courtesy of Gamma-Rapho/Getty Images; 6, 8, 10, 33, 36, 42, 62, 66, 84,
90–91, 92, 94, 100, 104–105, 115, 117, 128, 132–133, 134–135, 190, 194–195,
198–199, 212, and 219 courtesy of Heritage Images/Getty Images; pages 54–55,
56 courtesy of Imagno/Getty Images; page 172 courtesy of Leemage/Getty Images;
page 34 courtesy of Moment/Getty Images; pages 12, 24–25, 50, 98, 149, 164, and
184, courtesy of Mondadori/Getty Images; pages 29, 30, 53, 102, 120, 122, 124,
177, 182, 183, 192–193 and 216 courtesy of Print Collector/Getty Images; pages
61, 70–71, 79, 140, 143, 144, 153, 154, 158, 161, 162, 206, and 209 courtesy
of ShutterStock/Getty Images; and pages 26 and 138–139 courtesy of UIG/Getty
Images.

Black Dog & Leventhal Publishers
Hachette Book Group
1290 Avenue of the Americas
New York, NY 10104
www.blackdogandleventhal.com

Printed in Malaysia

Cover and interior design by Liz Driesbach

IM

First Edition: September 2015
10 9 8 7 6 5 4 3 2 1

Black Dog & Leventhal Publishers is an imprint of Hachette Books,
a division of Hachette Book Group.

The Black Dog & Leventhal Publishers name and logo are trademarks
of Hachette Book Group, Inc.

The Hachette Speakers Bureau provides a wide range of authors for speaking
events. To find out more, go to www.HachetteSpeakersBureau.com or call
(866) 376-6591.

The publisher is not responsible for websites (or their content)
that are not owned by the publisher.

Library of Congress Cataloging-in-Publication Data available upon request.

ISBN: 978-1-6319-1003-6

CONTENTS

Birth and Childhood

Christ the Preacher

The Passion

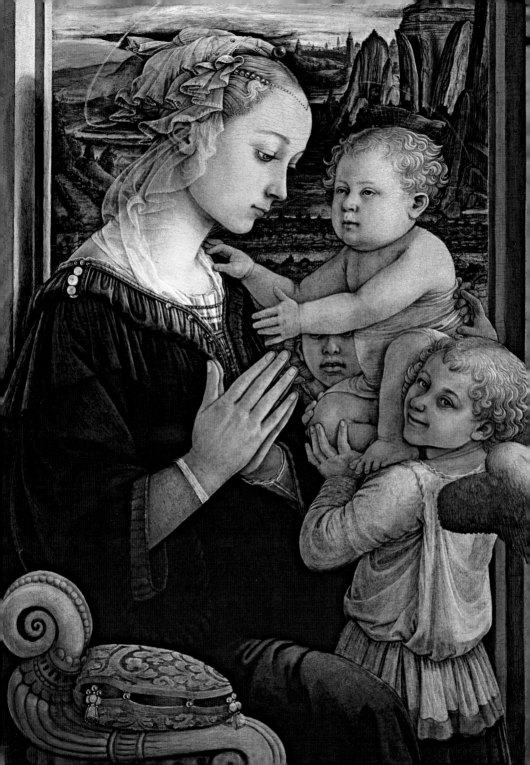

BIRTH AND CHILDHOOD

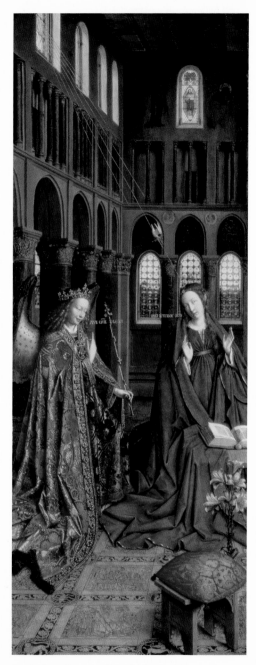

Sandro Botticelli, 1445–1510; *The Annunciation*,
1489–1490; Uffizi Gallery, Florence

THE ANNUNCIATION

Luke 1:26–38

nd in the sixth month the angel Gabriel was sent from God unto a city of Galilee, named Nazareth,

²⁷ To a virgin espoused to a man whose name was Joseph, of the house of David; and the virgin's name *was* Mary.

²⁸ And the angel came in unto her, and said, Hail, *thou that art* highly favoured, the Lord *is* with thee: blessed *art* thou among women.

²⁹ And when she saw *him*, she was troubled at his saying, and cast in her mind what manner of salutation this should be.

³⁰ And the angel said unto her, Fear not, Mary: for thou hast found favour with God.

³¹ And, behold, thou shalt conceive in thy womb, and bring forth a son, and shalt call his name JESUS.

³² He shall be great, and shall be called the Son of the Highest: and the Lord God shall give unto him the throne of his father David:

³³ And he shall reign over the house of Jacob for ever; and of his kingdom there shall be no end.

³⁴ Then said Mary unto the angel, How shall this be, seeing I know not a man?

³⁵ And the angel answered and said unto her, The Holy Ghost shall come upon thee, and the power of the Highest shall overshadow thee: therefore also that holy thing which shall be born of thee shall be called the Son of God.

³⁶ And, behold, thy cousin Elisabeth, she hath also conceived a son in her old age: and this is the sixth month with her, who was called barren.

³⁷ For with God nothing shall be impossible.

³⁸ And Mary said, Behold the handmaid of the Lord; be it unto me according to thy word. And the angel departed from her.

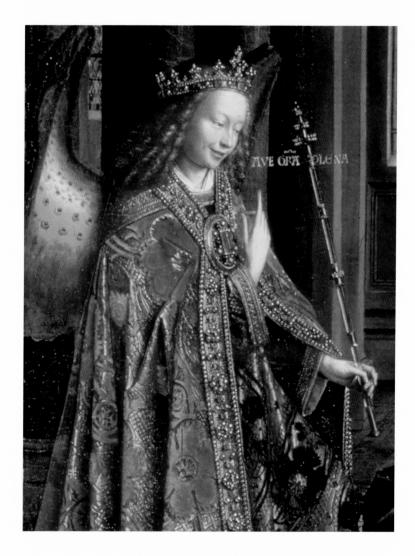

VISITATION (ELIZABETH)

Luke 1:39–56

nd Mary arose in those days, and went into the hill country with haste, into a city of Juda;

⁴⁰ And entered into the house of Zacharias, and saluted Elisabeth.

⁴¹ And it came to pass, that, when Elisabeth heard the salutation of Mary, the babe leaped in her womb; and Elisabeth was filled with the Holy Ghost:

⁴² And she spake out with a loud voice, and said, Blessed *art* thou among women, and blessed *is* the fruit of thy womb.

⁴³ And whence *is* this to me, that the mother of my Lord should come to me?

⁴⁴ For, lo, as soon as the voice of thy salutation sounded in mine ears, the babe leaped in my womb for joy.

⁴⁵ And blessed *is* she that believed: for there shall be a performance of those things which were told her from the Lord.

⁴⁶ And Mary said, My soul doth magnify the Lord,

⁴⁷ And my spirit hath rejoiced in God my Saviour.

⁴⁸ For he hath regarded the low estate of his handmaiden: for, behold, from henceforth all generations shall call me blessed.

⁴⁹ For he that is mighty hath done to me great things; and holy *is* his name.

⁵⁰ And his mercy *is* on them that fear him from generation to generation.

⁵¹ He hath shewed strength with his arm; he hath scattered the proud in the imagination of their hearts.

⁵² He hath put down the mighty from *their* seats, and exalted them of low degree.

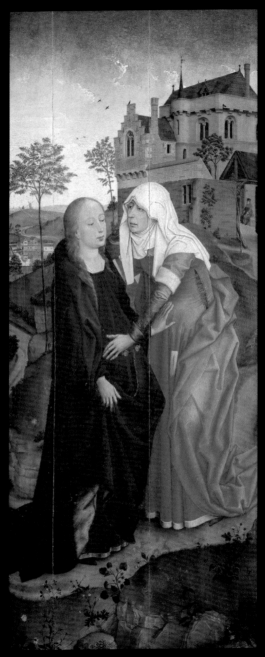

Rogier Van der Weyden, 1400–1464; *The Visitation*, 1434;
Museum der Bildenden Künste, Leipzig

⁵³ He hath filled the hungry with good things; and the rich he hath sent empty away.

⁵⁴ He hath holpen his servant Israel, in remembrance of *his* mercy;

⁵⁵ As he spake to our fathers, to Abraham, and to his seed for ever.

⁵⁶ And Mary abode with her about three months, and returned to her own house.

THE NATIVITY

Luke 2:15–20

nd it came to pass in those days, that there went out a decree from Caesar Augustus, that all the world should be taxed.

² (*And* this taxing was first made when Cyrenius was governor of Syria.)

³ And all went to be taxed, every one into his own city.

⁴ And Joseph also went up from Galilee, out of the city of Nazareth, into Judaea, unto the city of David, which is called Bethlehem; (because he was of the house and lineage of David:)

⁵ To be taxed with Mary his espoused wife, being great with child.

⁶ And so it was, that, while they were there, the days were accomplished that she should be delivered.

⁷ And she brought forth her firstborn son, and wrapped him in swaddling clothes, and laid him in a manger; because there was no room for them in the inn.

⁸ And there were in the same country shepherds abiding in the field, keeping watch over their flock by night.

⁹ And, lo, the angel of the Lord came upon them, and the glory of the Lord shone round about them: and they were sore afraid.

¹⁰ And the angel said unto them, Fear not: for, behold, I bring you good tidings of great joy, which shall be to all people.

¹¹ For unto you is born this day in the city of David a Saviour, which is Christ the Lord.

¹² And this *shall be* a sign unto you; Ye shall find the babe

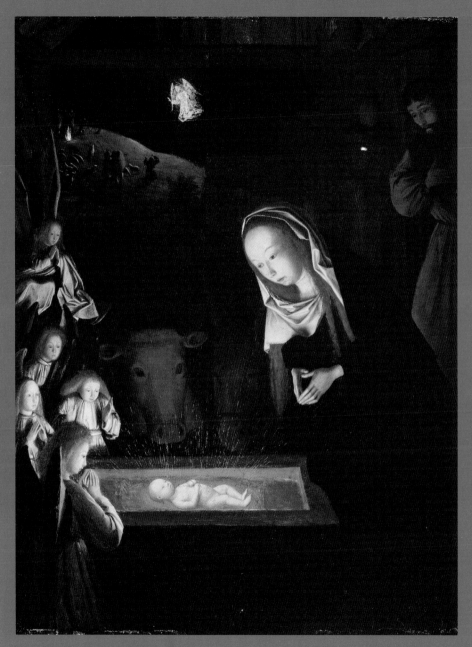

Geertgen Tot Sint Jans, ca. 1465–1495; *Nativity at Night*, 1490; National Gallery, London

wrapped in swaddling clothes, lying in a manger.

¹³ And suddenly there was with the angel a multitude of the heavenly host praising God, and saying,

¹⁴ Glory to God in the highest, and on earth peace, good will toward men.

¹⁵ And it came to pass, as the angels were gone away from them into heaven, the shepherds said one to another, Let us now go even unto Bethlehem, and see this thing which is come to pass, which the Lord hath made known unto us.

¹⁶ And they came with haste, and found Mary, and Joseph, and the babe lying in a manger.

ow the birth of Jesus Christ was on this wise: When as his mother Mary was espoused to Joseph, before they came together, she was found with child of the Holy Ghost.

¹⁹ Then Joseph her husband, being a just *man*, and not willing to make her a publick example, was minded to put her away privily.

²⁰ But while he thought on these things, behold, the angel of the Lord appeared unto him in a dream, saying, Joseph, thou son of David, fear not to take unto thee Mary thy wife: for that which is conceived in her is of the Holy Ghost.

²¹ And she shall bring forth a son, and thou shalt call his name JESUS: for he shall save his people from their sins.

²² Now all this was done, that it might be fulfilled which was spoken of the Lord by the prophet, saying,

²³ Behold, a virgin shall be with child, and shall bring forth a son, and they shall call his name Emmanuel, which being interpreted is, God with us.

²⁴ Then Joseph being raised from sleep did as the angel of the Lord had bidden him, and took unto him his wife:

²⁵ And knew her not till she had brought forth her firstborn son: and he called his name JESUS.

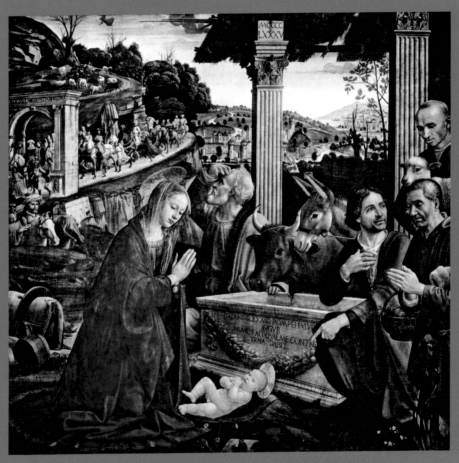

Domenico Ghirlandaio, 1443–1449; *Adoration of the Shepherds*, 1485; Church of Santa Trinita, Florence

ADORATION OF
THE SHEPHERDS

Luke 2:17–20

 nd when they had seen *it*, they made known abroad the saying which was told them concerning this child.

[18] And all they that heard *it* wondered at those things which were told them by the shepherds.

[19] But Mary kept all these things, and pondered *them* in her heart.

[20] And the shepherds returned, glorifying and praising God for all the things that they had heard and seen, as it was told unto them.

Hieronymus Bosch,
1450–1516;
*Adoration of the
Magi*, 16th century;
Prado Museum,
Madrid

ADORATION
OF THE MAGI

Matthew 2:1–12

ow when Jesus was born in Bethlehem of Judaea in the days of Herod the king, behold, there came wise men from the east to Jerusalem,

² Saying, Where is he that is born King of the Jews? for we have seen his star in the east, and are come to worship him.

³ When Herod the king had heard *these things*, he was troubled, and all Jerusalem with him.

⁴ And when he had gathered all the chief priests and scribes of the people together, he demanded of them where Christ should be born.

⁵ And they said unto him, In Bethlehem of Judaea: for thus it is written by the prophet,

⁶ And thou Bethlehem, *in* the land of Juda, art not the least among the princes of Juda: for out of thee shall come a Governor, that shall rule my people Israel.

⁷ Then Herod, when he had privily called the wise men, enquired of them diligently what time the star appeared.

⁸ And he sent them to Bethlehem, and said, Go and search diligently for the young child; and when ye have found *him*, bring me word again, that I may come and worship him also.

⁹ When they had heard the king, they departed; and, lo, the star, which they saw in the east, went before them, till it came and stood over where the young child was.

¹⁰ When they saw the star, they rejoiced with exceeding great joy.

¹¹ And when they were come into the house, they saw the young child with Mary his mother, and fell down, and worshipped him: and when they had opened their treasures, they presented unto him gifts; gold, and frankincense, and myrrh.

¹² And being warned of God in a dream that they should not return to Herod, they departed into their own country another way.

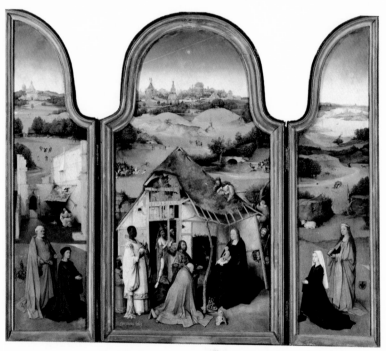

Hieronymus Bosch, 1450–1516; *Adoration of the Magi*, 16th century; Prado Museum, Madrid

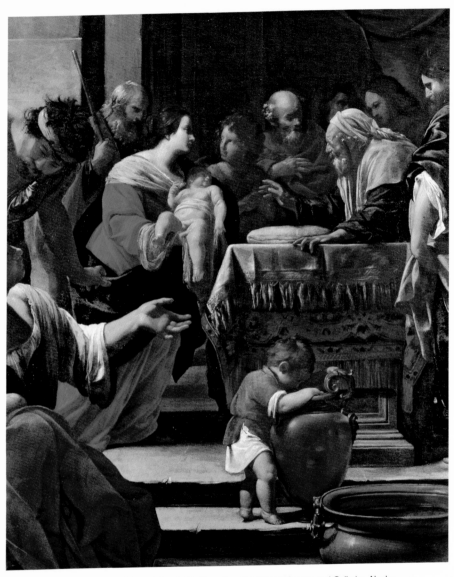

Simon Vouet, 1590–1640; *The Circumcision*, 1622; Capodimonte National Museum and Galleries, Naples

CIRCUMCISION

Luke 2:21

nd when eight days were accomplished for the circumcising of the child, his name was called JESUS, which was so named of the angel before he was conceived in the womb.

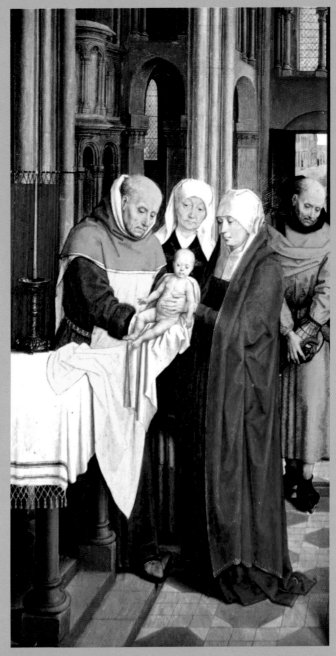

Hans Memling, ca. 1430–1494; *Floreins Triptych: Presentation of Jesus at the Temple*, 1470s; Memling Museum, Bruges

PRESENTATION AT THE TEMPLE

Luke 2:22–41

 nd when the days of her purification according to the law of Moses were accomplished, they brought him to Jerusalem, to present *him* to the Lord;

²³ (As it is written in the law of the Lord, Every male that openeth the womb shall be called holy to the Lord;)

²⁴ And to offer a sacrifice according to that which is said in the law of the Lord, A pair of turtledoves, or two young pigeons.

²⁵ And, behold, there was a man in Jerusalem, whose name *was* Simeon; and the same man *was* just and devout, waiting for the consolation of Israel: and the Holy Ghost was upon him.

²⁶ And it was revealed unto him by the Holy Ghost, that he should not see death, before he had seen the Lord's Christ.

²⁷ And he came by the Spirit into the temple: and when the parents brought in the child Jesus, to do for him after the custom of the law,

²⁸ Then took he him up in his arms, and blessed God, and said,

²⁹ Lord, now lettest thou thy servant depart in peace, according to thy word:

³⁰ For mine eyes have seen thy salvation,

³¹ Which thou hast prepared before the face of all people;

³² A light to lighten the Gentiles, and the glory of thy people Israel.

³³ And Joseph and his mother marvelled at those things which were spoken of him.

³⁴ And Simeon blessed them, and said unto Mary his mother,

Behold, this *child* is set for the fall and rising again of many in Israel; and for a sign which shall be spoken against;

³⁵ (Yea, a sword shall pierce through thy own soul also,) that the thoughts of many hearts may be revealed.

³⁶ And there was one Anna, a prophetess, the daughter of Phanuel, of the tribe of Aser: she was of a great age, and had lived with an husband seven years from her virginity;

³⁷ And she *was* a widow of about fourscore and four years, which departed not from the temple, but served *God* with fastings and prayers night and day.

³⁸ And she coming in that instant gave thanks likewise unto the Lord, and spake of him to all them that looked for redemption in Jerusalem.

³⁹ And when they had performed all things according to the law of the Lord, they returned into Galilee, to their own city Nazareth.

⁴⁰ And the child grew, and waxed strong in spirit, filled with wisdom: and the grace of God was upon him.

⁴¹ Now his parents went to Jerusalem every year at the feast of the passover.

FLIGHT INTO EGYPT

Matthew 2:12–23

 nd being warned of God in a dream that they should not return to Herod, they departed into their own country another way.

13 And when they were departed, behold, the angel of the Lord appeareth to Joseph in a dream, saying, Arise, and take the young child and his mother, and flee into Egypt, and be thou there until I bring thee word: for Herod will seek the young child to destroy him.

14 When he arose, he took the young child and his mother by night, and departed into Egypt:

15 And was there until the death of Herod: that it might be fulfilled which was spoken of

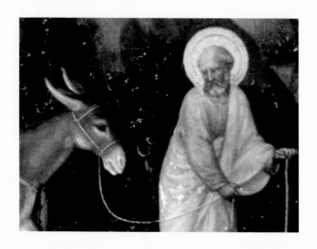

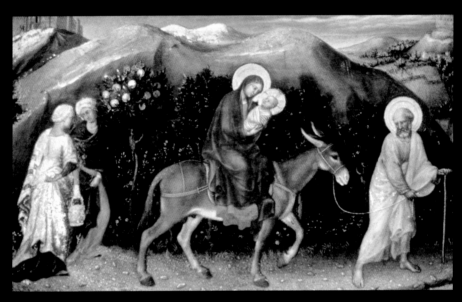

Gentile da Fabriano, ca. 1385–1427; *Flight into Egypt*, 1423; Uffizi Gallery, Florence

the Lord by the prophet, saying, Out of Egypt have I called my son.

¹⁶ Then Herod, when he saw that he was mocked of the wise men, was exceeding wroth, and sent forth, and slew all the children that were in Bethlehem, and in all the coasts thereof, from two years old and under, according to the time which he had diligently enquired of the wise men.

¹⁷ Then was fulfilled that which was spoken by Jeremy the prophet, saying,

¹⁸ In Rama was there a voice heard, lamentation, and weeping, and great mourning, Rachel weeping *for* her children, and would not be comforted, because they are not.

¹⁹ But when Herod was dead, behold, an angel of the Lord appeareth in a dream to Joseph in Egypt,

²⁰ Saying, Arise, and take the young child and his mother, and go into the land of Israel: for they are dead which sought the young child's life.

²¹ And he arose, and took the young child and his mother, and came into the land of Israel.

²² But when he heard that Archelaus did reign in Judaea in the room of his father Herod, he was afraid to go thither: notwithstanding, being warned of God in a dream, he turned aside into the parts of Galilee:

²³ And he came and dwelt in a city called Nazareth: that it might be fulfilled which was spoken by the prophets, He shall be called a Nazarene.

CHRIST AMONG THE DOCTORS

Luke 2:42–52

nd when he was twelve years old, they went up to Jerusalem after the custom of the feast.

⁴³ And when they had fulfilled the days, as they returned, the child Jesus tarried behind in Jerusalem; and Joseph and his mother knew not *of it*.

⁴⁴ But they, supposing him to have been in the company, went a day's journey; and they sought him among *their* kinsfolk and acquaintance.

⁴⁵ And when they found him not, they turned back again to Jerusalem, seeking him.

⁴⁶ And it came to pass, that after three days they found him in the temple, sitting in the midst of the doctors, both hearing them, and asking them questions.

⁴⁷ And all that heard him were astonished at his understanding and answers.

⁴⁸ And when they saw him, they were amazed: and his mother said unto him, Son, why hast thou thus dealt with us? behold, thy father and I have sought thee sorrowing.

⁴⁹ And he said unto them, How is it that ye sought me? wist ye not that I must be about my Father's business?

⁵⁰ And they understood not the saying which he spake unto them.

⁵¹ And he went down with them, and came to Nazareth, and was subject unto them: but his mother kept all these sayings in her heart.

⁵² And Jesus increased in wisdom and stature, and in favour with God and man.

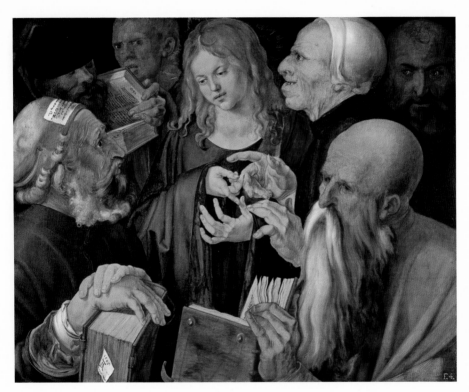

Albrecht Dürer, 1471–1528; *Christ Among the Doctors*, 1508; Thyssen–Bornemisza Museum, Madrid

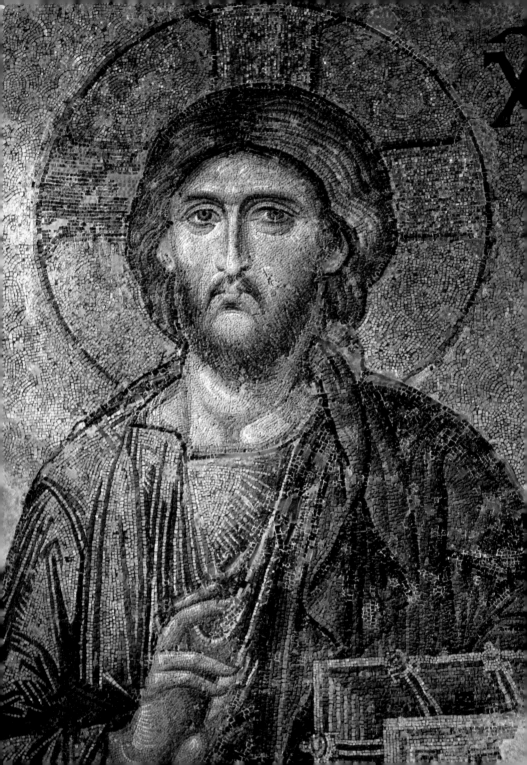

The *Deësis Mosaic*, 13th century;
Hagia Sophia, Istanbul

CHRIST
THE PREACHER

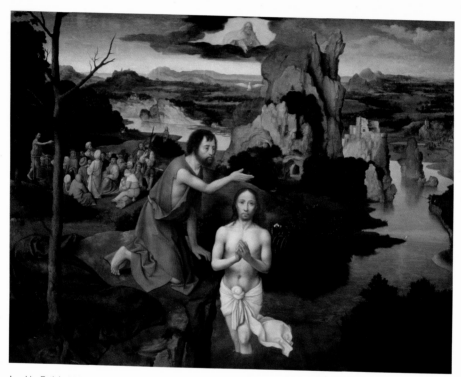

Joachim Patinir, 1480–1524; *The Baptism of Christ*, ca. 1515; Art History Museum, Vienna

BAPTISM
OF JESUS

Mark 1:1–27

he beginning of the gospel of Jesus Christ, the Son of God;

2 As it is written in the prophets, Behold, I send my messenger before thy face, which shall prepare thy way before thee.

3 The voice of one crying in the wilderness, Prepare ye the way of the Lord, make his paths straight.

4 John did baptize in the wilderness, and preach the baptism of repentance for the remission of sins.

5 And there went out unto him all the land of Judaea, and they of Jerusalem, and were all baptized of him in the river of Jordan, confessing their sins.

6 And John was clothed with camel's hair, and with a girdle of a skin about his loins; and he did eat locusts and wild honey;

7 And preached, saying, There cometh one mightier than I after me, the latchet of whose shoes I am not worthy to stoop down and unloose.

8 I indeed have baptized you with water: but he shall baptize you with the Holy Ghost.

9 And it came to pass in those days, that Jesus came from Nazareth of Galilee, and was baptized of John in Jordan.

10 And straightway coming up out of the water, he saw the heavens opened, and the Spirit like a dove descending upon him:

11 And there came a voice from heaven, *saying*, Thou art my beloved Son, in whom I am well pleased.

12 And immediately the Spirit driveth him into the wilderness.

13 And he was there in the

wilderness forty days, tempted of Satan; and was with the wild beasts; and the angels ministered unto him.

¹⁴ Now after that John was put in prison, Jesus came into Galilee, preaching the gospel of the kingdom of God,

¹⁵ And saying, The time is fulfilled, and the kingdom of God is at hand: repent ye, and believe the gospel.

¹⁶ Now as he walked by the sea of Galilee, he saw Simon and Andrew his brother casting a net into the sea: for they were fishers.

¹⁷ And Jesus said unto them, Come ye after me, and I will make you to become fishers of men.

¹⁸ And straightway they forsook their nets, and followed him.

¹⁹ And when he had gone a little further thence, he saw James the *son* of Zebedee, and John his brother, who also were in the ship mending their nets.

²⁰ And straightway he called them: and they left their father Zebedee in the ship with the hired servants, and went after him.

²¹ And they went into Capernaum; and straightway on the sabbath day he entered into the synagogue, and taught.

²² And they were astonished at his doctrine: for he taught them as one that had authority, and not as the scribes.

²³ And there was in their synagogue a man with an unclean spirit; and he cried out,

²⁴ Saying, Let *us* alone; what have we to do with thee, thou Jesus of Nazareth? art thou come to destroy us? I know thee who thou art, the Holy One of God.

²⁵ And Jesus rebuked him, saying, Hold thy peace, and come out of him.

²⁶ And when the unclean spirit had torn him, and cried with a loud voice, he came out of him.

²⁷ And they were all amazed, insomuch that they questioned among themselves, saying, What thing is this? what new doctrine *is* this? for with authority commandeth he even the unclean spirits, and they do obey him.

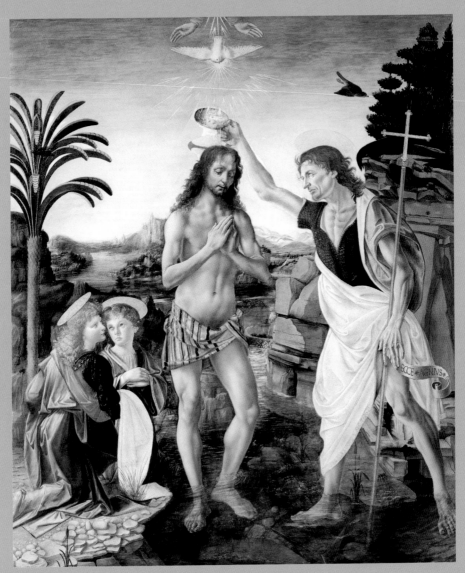

Andrea del Verrocchio, 1437–1488, Leonardo da Vinci, 1452–1519; *Baptism of Christ*, 1472–1475; Uffizi Gallery, Florence

n the beginning was the Word, and the Word was with God, and the Word was God.

² The same was in the beginning with God.

³ All things were made by him; and without him was not any thing made that was made.

⁴ In him was life; and the life was the light of men.

⁵ And the light shineth in darkness; and the darkness comprehended it not.

⁶ There was a man sent from God, whose name *was* John.

⁷ The same came for a witness, to bear witness of the Light, that all *men* through him might believe.

⁸ He was not that Light, but *was sent* to bear witness of that Light.

⁹ *That* was the true Light, which lighteth every man that cometh into the world.

¹⁰ He was in the world, and the world was made by him, and the world knew him not.

¹¹ He came unto his own, and his own received him not.

¹² But as many as received him, to them gave he power to become the sons of God, *even to* them that believe on his name:

¹³ Which were born, not of blood, nor of the will of the flesh, nor of the will of man, but of God.

¹⁴ And the Word was made flesh, and dwelt among us, (and we beheld his glory, the glory as of the only begotten of the Father,) full of grace and truth.

¹⁵ John bare witness of him, and cried, saying, This was he of whom I spake, He that cometh after me is preferred before me: for he was before me.

¹⁶ And of his fulness have all we received, and grace for grace.

¹⁷ For the law was given by Moses, *but* grace and truth came by Jesus Christ.

¹⁸ No man hath seen God at any time; the only begotten Son, which is in the bosom of the Father, he hath declared *him*.

¹⁹ And this is the record of John, when the Jews sent priests and Levites from Jerusalem to ask him, Who art thou?

²⁰ And he confessed, and denied not; but confessed, I am not the Christ.

²¹ And they asked him, What then? Art thou Elias? And he saith, I am not. Art thou that prophet? And he answered, No.

²² Then said they unto him, Who art thou? that we may give an answer to them that sent us. What sayest thou of thyself?

²³ He said, I *am* the voice of one crying in the wilderness, Make straight the way of the Lord, as said the prophet Esaias.

²⁴ And they which were sent were of the Pharisees.

²⁵ And they asked him, and said unto him, Why baptizest thou then, if thou be not that Christ, nor Elias, neither that prophet?

²⁶ John answered them, saying, I baptize with water: but there standeth one among you, whom ye know not;

²⁷ He it is, who coming after me is preferred before me, whose shoe's latchet I am not worthy to unloose.

²⁸ These things were done in Bethabara beyond Jordan, where John was baptizing.

²⁹ The next day John seeth Jesus coming unto him, and saith, Behold the Lamb of God, which taketh away the sin of the world.

³⁰ This is he of whom I said, After me cometh a man which is preferred before me: for he was before me.

³¹ And I knew him not: but that he should be made manifest to Israel, therefore am I come baptizing with water.

³² And John bare record, saying, I saw the Spirit descending from heaven like a dove, and it abode upon him.

³³ And I knew him not: but he that sent me to baptize with water, the same said unto me, Upon whom thou shalt see the Spirit descending, and remaining on him, the same is he which baptizeth with the Holy Ghost.

³⁴ And I saw, and bare record that this is the Son of God.

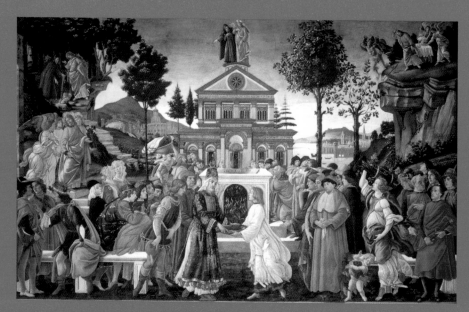

Sandro Botticelli, 1445–1510; *The Temptation of Christ*, 1481–1482; Sistine Chapel, Vatican Museums

TEMPTATION OF JESUS

Matthew 4:1–11

Then was Jesus led up of the Spirit into the wilderness to be tempted of the devil.

² And when he had fasted forty days and forty nights, he was afterward an hungred.

³ And when the tempter came to him, he said, If thou be the Son of God, command that these stones be made bread.

⁴ But he answered and said, It is written, Man shall not live by bread alone, but by every word that proceedeth out of the mouth of God.

⁵ Then the devil taketh him up into the holy city, and setteth him on a pinnacle of the temple,

⁶ And saith unto him, If thou be the Son of God, cast thyself down: for it is written, He shall give his angels charge concerning thee: and in *their* hands they shall bear thee up, lest at any time thou dash thy foot against a stone.

⁷ Jesus said unto him, It is written again, Thou shalt not tempt the Lord thy God.

⁸ Again, the devil taketh him up into an exceeding high mountain, and sheweth him all the kingdoms of the world, and the glory of them;

⁹ And saith unto him, All these things will I give thee, if thou wilt fall down and worship me.

¹⁰ Then saith Jesus unto him, Get thee hence, Satan: for it is written, Thou shalt worship the Lord thy God, and him only shalt thou serve.

¹¹ Then the devil leaveth him, and, behold, angels came and ministered unto him.

nd Jesus being full of the Holy Ghost returned from Jordan, and was led by the Spirit into the wilderness,

2 Being forty days tempted of the devil. And in those days he did eat nothing: and when they were ended, he afterward hungered.

3 And the devil said unto him, If thou be the Son of God, command this stone that it be made bread.

4 And Jesus answered him, saying, It is written, That man shall not live by bread alone, but by every word of God.

5 And the devil, taking him up into an high mountain, shewed unto him all the kingdoms of the world in a moment of time.

6 And the devil said unto him, All this power will I give thee, and the glory of them: for that is delivered unto me; and to whomsoever I will I give it.

7 If thou therefore wilt worship me, all shall be thine.

8 And Jesus answered and said unto him, Get thee behind me, Satan: for it is written, Thou shalt worship the Lord thy God, and him only shalt thou serve.

9 And he brought him to Jerusalem, and set him on a pinnacle of the temple, and said unto him, If thou be the Son of God, cast thyself down from hence:

10 For it is written, He shall give his angels charge over thee, to keep thee:

11 And in *their* hands they shall bear thee up, lest at any time thou dash thy foot against a stone.

12 And Jesus answering said unto him, It is said, Thou shalt not tempt the Lord thy God.

13 And when the devil had ended all the temptation, he departed from him for a season.

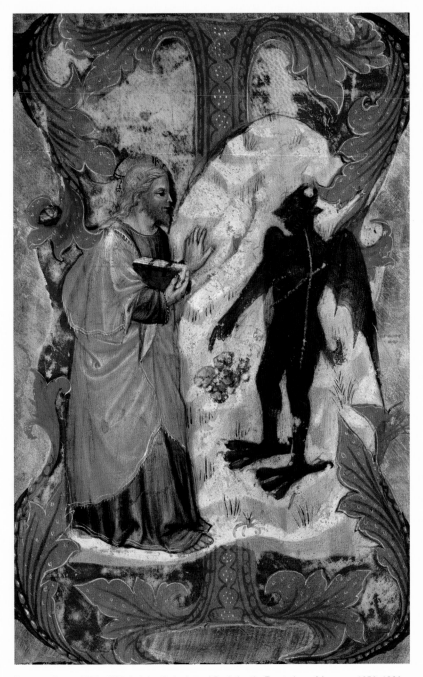

Turone, active ca. 1356–1380; *Incipit with the Letter I Depicting the Temptations of Jesus*, ca. 1356–1380

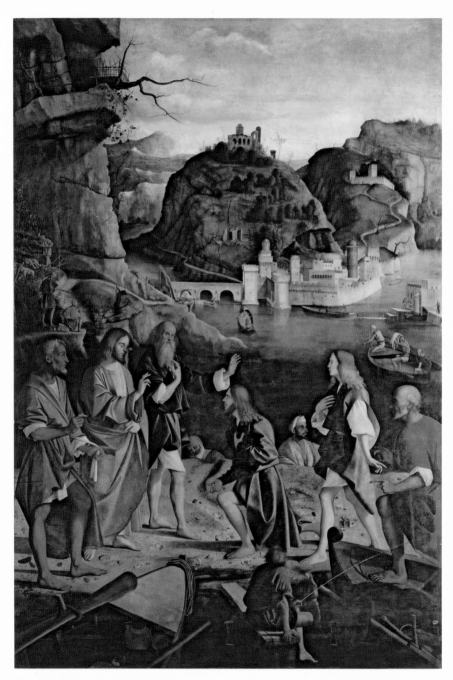

Marco Basaiti, ca. 1470–1530; *Panel Depicting the Vocation of Zebedee's Sons*, 1510; Accademia, Venice

CALLING OF
THE APOSTLES

Mark 1:14–28

ow after that John was put in prison, Jesus came into Galilee, preaching the gospel of the kingdom of God,

¹⁵ And saying, The time is fulfilled, and the kingdom of God is at hand: repent ye, and believe the gospel.

¹⁶ Now as he walked by the sea of Galilee, he saw Simon and Andrew his brother casting a net into the sea: for they were fishers.

¹⁷ And Jesus said unto them, Come ye after me, and I will make you to become fishers of men.

¹⁸ And straightway they forsook their nets, and followed him.

¹⁹ And when he had gone a little further thence, he saw James the *son* of Zebedee, and John his brother, who also were in the ship mending their nets.

²⁰ And straightway he called them: and they left their father Zebedee in the ship with the hired servants, and went after him.

²¹ And they went into Capernaum; and straightway on the sabbath day he entered into the synagogue, and taught.

²² And they were astonished at his doctrine: for he taught them as one that had authority, and not as the scribes.

²³ And there was in their synagogue a man with an unclean spirit; and he cried out,

²⁴ Saying, Let *us* alone; what have we to do with thee, thou Jesus of Nazareth? art thou come to destroy us? I know thee who thou art, the Holy One of God.

²⁵ And Jesus rebuked him, saying, Hold thy peace, and come out of him.

²⁶ And when the unclean spirit had torn him, and cried with a loud voice, he came out of him.

²⁷ And they were all amazed, insomuch that they questioned among themselves, saying, What thing is this? what new doctrine *is* this? for with authority commandeth he even the unclean spirits, and they do obey him.

²⁸ And immediately his fame spread abroad throughout all the region round about Galilee.

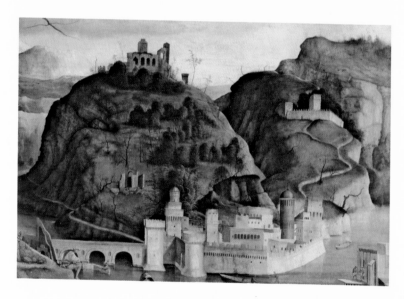

John 1:35–51

gain the next day after John stood, and two of his disciples;

36 And looking upon Jesus as he walked, he saith, Behold the Lamb of God!

37 And the two disciples heard him speak, and they followed Jesus.

38 Then Jesus turned, and saw them following, and saith unto them, What seek ye? They said unto him, Rabbi, (which is to say, being interpreted, Master,) where dwellest thou?

39 He saith unto them, Come and see. They came and saw where he dwelt, and abode with him that day: for it was about the tenth hour.

40 One of the two which heard John *speak*, and followed him, was Andrew, Simon Peter's brother.

41 He first findeth his own brother Simon, and saith unto him, We have found the Mes-sias, which is, being interpreted, the Christ.

42 And he brought him to Jesus. And when Jesus beheld him, he said, Thou art Simon the son of Jona: thou shalt be called Cephas, which is by inter-pretation, A stone.

43 The day following Jesus would go forth into Galilee, and findeth Philip, and saith unto him, Follow me.

44 Now Philip was of Beth-saida, the city of Andrew and Peter.

45 Philip findeth Nathanael, and saith unto him, We have found him, of whom Moses in the law, and the prophets, did write, Jesus of Nazareth, the son of Joseph.

46 And Nathanael said unto him, Can there any good thing come out of Nazareth? Philip saith unto him, Come and see.

47 Jesus saw Nathanael coming to him, and saith of him, Behold

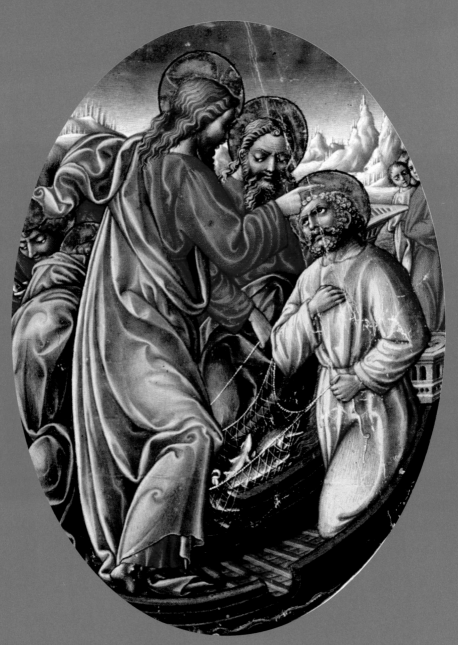

Liberale da Verona, 15th century; *Calling of Peter and Andrew*, 15th Century;
Cathedral of Santa Maria Assunta, Siena

an Israelite indeed, in whom is no guile!

⁴⁸ Nathanael saith unto him, Whence knowest thou me? Jesus answered and said unto him, Before that Philip called thee, when thou wast under the fig tree, I saw thee.

⁴⁹ Nathanael answered and saith unto him, Rabbi, thou art the Son of God; thou art the King of Israel.

⁵⁰ Jesus answered and said unto him, Because I said unto thee, I saw thee under the fig tree, believest thou? thou shalt see greater things than these.

⁵¹ And he saith unto him, Verily, verily, I say unto you, Hereafter ye shall see heaven open, and the angels of God ascending and descending upon the Son of man.

THE CALLING
OF ST. PETER

Luke 5:1–11

nd it came to pass, that, as the people pressed upon him to hear the word of God, he stood by the lake of Gennesaret,

2 And saw two ships standing by the lake: but the fishermen were gone out of them, and were washing *their* nets.

3 And he entered into one of the ships, which was Simon's, and prayed him that he would thrust out a little from the land. And he sat down, and taught the people out of the ship.

4 Now when he had left speaking, he said unto Simon, Launch out into the deep, and let down your nets for a draught.

5 And Simon answering said unto him, Master, we have toiled all the night, and have taken nothing: nevertheless at thy word I will let down the net.

6 And when they had this done, they inclosed a great multitude of fishes: and their net brake.

7 And they beckoned unto *their* partners, which were in the other ship, that they should come and help them. And they came, and filled both the ships, so that they began to sink.

8 When Simon Peter saw *it*, he fell down at Jesus' knees, saying, Depart from me; for I am a sinful man, O Lord.

9 For he was astonished, and all that were with him, at the draught of the fishes which they had taken:

10 And so *was* also James, and John, the sons of Zebedee, which were partners with Simon. And Jesus said unto Simon, Fear not; from henceforth thou shalt catch men.

11 And when they had brought their ships to land, they forsook all, and followed him.

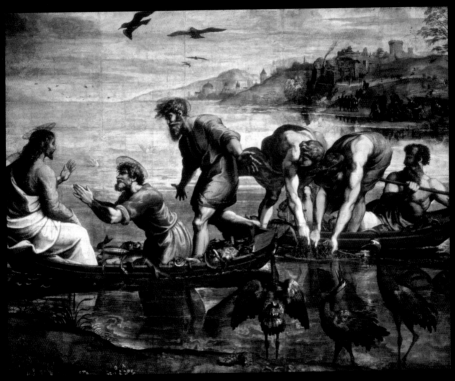

Raphael (Raffaello Sanzio), 1483–1520; *The Miraculous Draught of Fishes*, 1515; Victoria & Albert Museum, London

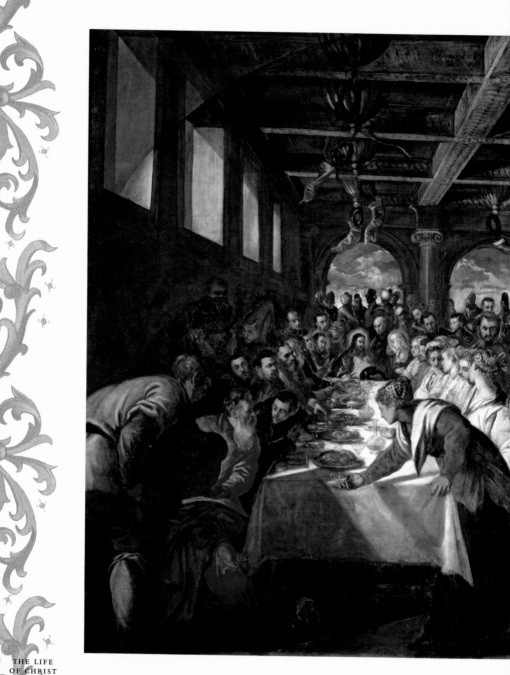

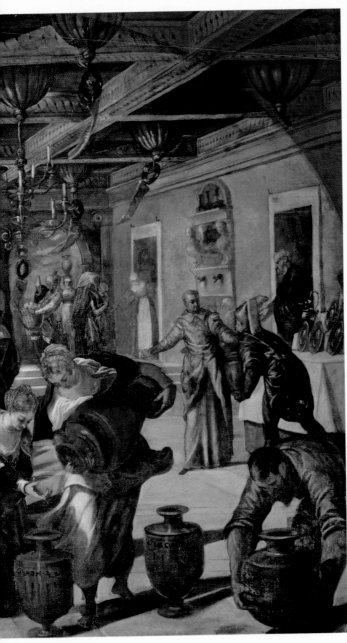

Gerard David, ca. 1460–1523; *The Marriage at Cana*, ca. 1500; Louvre, Paris

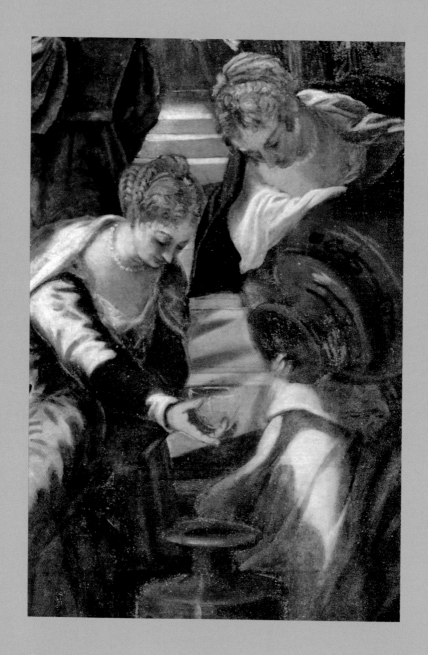

THE MARRIAGE AT CANA

John 2:1–12

And the third day there was a marriage in Cana of Galilee; and the mother of Jesus was there:

2 And both Jesus was called, and his disciples, to the marriage.

3 And when they wanted wine, the mother of Jesus saith unto him, They have no wine.

4 Jesus saith unto her, Woman, what have I to do with thee? mine hour is not yet come.

5 His mother saith unto the servants, Whatsoever he saith unto you, do *it*.

6 And there were set there six waterpots of stone, after the manner of the purifying of the Jews, containing two or three firkins apiece.

7 Jesus saith unto them, Fill the waterpots with water. And they filled them up to the brim.

8 And he saith unto them, Draw out now, and bear unto the governor of the feast. And they bare *it*.

9 When the ruler of the feast had tasted the water that was made wine, and knew not whence it was: (but the servants which drew the water knew;) the governor of the feast called the bridegroom,

10 And saith unto him, Every man at the beginning doth set forth good wine; and when men have well drunk, then that which is worse: *but* thou hast kept the good wine until now.

11 This beginning of miracles did Jesus in Cana of Galilee, and manifested forth his glory;

CHRIST
THE PREACHER

57

and his disciples believed on him. and his brethren, and his disci-
12 After this he went down to ples: and they continued there
Capernaum, he, and his mother, not many days.

CHRIST AND THE SAMARITAN WOMAN

John 4:1–42

hen therefore the Lord knew how the Pharisees had heard that Jesus made and baptized more disciples than John,

2 (Though Jesus himself baptized not, but his disciples,)

3 He left Judaea, and departed again into Galilee.

4 And he must needs go through Samaria.

5 Then cometh he to a city of Samaria, which is called Sychar, near to the parcel of ground that Jacob gave to his son Joseph.

6 Now Jacob's well was there. Jesus therefore, being wearied with *his* journey, sat thus on the well: *and* it was about the sixth hour.

7 There cometh a woman of Samaria to draw water: Jesus saith unto her, Give me to drink.

8 (For his disciples were gone away unto the city to buy meat.)

9 Then saith the woman of Samaria unto him, How is it that thou, being a Jew, askest drink of me, which am a woman of Samaria? for the Jews have no dealings with the Samaritans.

10 Jesus answered and said unto her, If thou knewest the gift of God, and who it is that saith to thee, Give me to drink; thou wouldest have asked of him, and he would have given thee living water.

11 The woman saith unto him, Sir, thou hast nothing to draw with, and the well is deep: from whence then hast thou that living water?

12 Art thou greater than our father Jacob, which gave us the well, and drank thereof himself, and his children, and his cattle?

¹³ Jesus answered and said unto her, Whosoever drinketh of this water shall thirst again:

¹⁴ But whosoever drinketh of the water that I shall give him shall never thirst; but the water that I shall give him shall be in him a well of water springing up into everlasting life.

¹⁵ The woman saith unto him, Sir, give me this water, that I thirst not, neither come hither to draw.

¹⁶ Jesus saith unto her, Go, call thy husband, and come hither.

¹⁷ The woman answered and said, I have no husband. Jesus said unto her, Thou hast well said, I have no husband:

¹⁸ For thou hast had five husbands; and he whom thou now hast is not thy husband: in that saidst thou truly.

¹⁹ The woman saith unto him, Sir, I perceive that thou art a prophet.

²⁰ Our fathers worshipped in this mountain; and ye say, that in Jerusalem is the place where men ought to worship.

²¹ Jesus saith unto her, Woman, believe me, the hour cometh, when ye shall neither in this mountain, nor yet at Jerusalem, worship the Father.

²² Ye worship ye know not what: we know what we worship: for salvation is of the Jews.

²³ But the hour cometh, and now is, when the true worshippers shall worship the Father in spirit and in truth: for the Father seeketh such to worship him.

²⁴ God *is* a Spirit: and they that worship him must worship *him* in spirit and in truth.

²⁵ The woman saith unto him, I know that Messias cometh, which is called Christ: when he is come, he will tell us all things.

²⁶ Jesus saith unto her, I that speak unto thee am *he.*

²⁷ And upon this came his disciples, and marvelled that he talked with the woman: yet no man said, What seekest thou? or, Why talkest thou with her?

²⁸ The woman then left her waterpot, and went her way into the city, and saith to the men,

²⁹ Come, see a man, which told me all things that ever I did: is not this the Christ?

³⁰ Then they went out of the city, and came unto him.

³¹ In the mean while his disciples prayed him, saying, Master, eat.

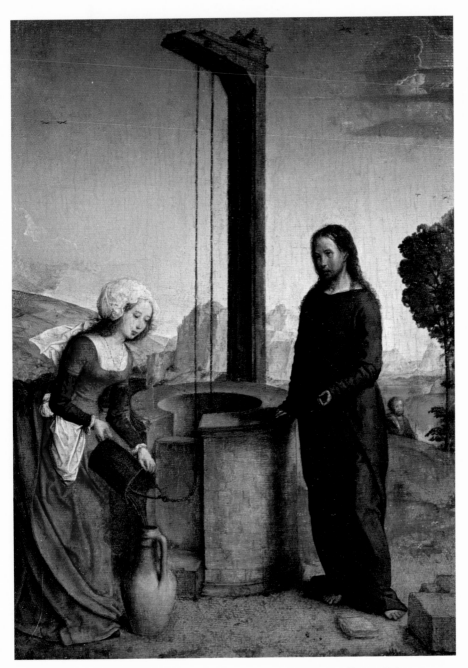

Juan de Flandes, ca. 1460–1519; *Christ and the Woman of Samaria*, 1496–1504; Louvre Museum, Paris

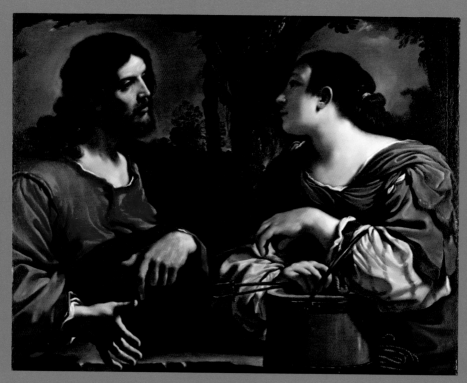

Guercino (Giovanni Francesco Barbieri), 1591–1666; *Christ and the Samaritan Woman at Jacob's Well*, ca. 1619–20; Kimbell Art Museum, Texas

³² But he said unto them, I have meat to eat that ye know not of.

³³ Therefore said the disciples one to another, Hath any man brought him *ought* to eat?

³⁴ Jesus saith unto them, My meat is to do the will of him that sent me, and to finish his work.

³⁵ Say not ye, There are yet four months, and *then* cometh harvest? behold, I say unto you, Lift up your eyes, and look on the fields; for they are white already to harvest.

³⁶ And he that reapeth receiveth wages, and gathereth fruit unto life eternal: that both he that soweth and he that reapeth may rejoice together.

³⁷ And herein is that saying true, One soweth, and another reapeth.

³⁸ I sent you to reap that whereon ye bestowed no labour: other men laboured, and ye are entered into their labours.

³⁹ And many of the Samaritans of that city believed on him for the saying of the woman, which testified, He told me all that ever I did.

⁴⁰ So when the Samaritans were come unto him, they besought him that he would tarry with them: and he abode there two days.

⁴¹ And many more believed because of his own word;

⁴² And said unto the woman, Now we believe, not because of thy saying: for we have heard *him* ourselves, and know that this is indeed the Christ, the Saviour of the world.

CHRIST HEALS THE LEPER

Matthew 8:1–4

 hen he was come down from the mountain, great multitudes followed him.

² And, behold, there came a leper and worshipped him, saying, Lord, if thou wilt, thou canst make me clean.

³ And Jesus put forth *his* hand, and touched him, saying, I will; be thou clean. And immediately his leprosy was cleansed.

⁴ And Jesus saith unto him, See thou tell no man; but go thy way, shew thyself to the priest, and offer the gift that Moses commanded, for a testimony unto them.

Illumination Depicting Christ Healing the Leper, in the *Codex De Predis* (c.49r), 15ᵗʰ century; Royal Library in Turin

THE HEALING OF THE PARALYTICS

Mark 2:1–12

nd again he entered into Capernaum after *some* days; and it was noised that he was in the house.

² And straightway many were gathered together, insomuch that there was no room to receive *them*, no, not so much as about the door: and he preached the word unto them.

³ And they come unto him, bringing one sick of the palsy, which was borne of four.

⁴ And when they could not come nigh unto him for the press, they uncovered the roof where he was: and when they had broken *it* up, they let down the bed wherein the sick of the palsy lay.

⁵ When Jesus saw their faith, he said unto the sick of the palsy, Son, thy sins be forgiven thee.

⁶ But there were certain of the scribes sitting there, and reasoning in their hearts,

⁷ Why doth this *man* thus speak blasphemies? who can forgive sins but God only?

⁸ And immediately when Jesus perceived in his spirit that they so reasoned within themselves, he said unto them, Why reason ye these things in your hearts?

⁹ Whether is it easier to say to the sick of the palsy, *Thy* sins be forgiven thee; or to say, Arise, and take up thy bed, and walk?

¹⁰ But that ye may know that the Son of man hath power on earth to forgive sins, (he saith to the sick of the palsy,)

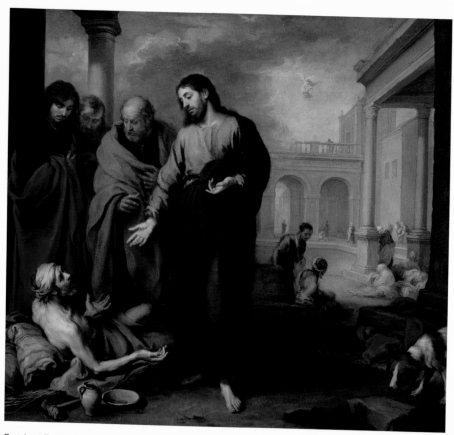

Bartolomé Esteban Murillo, 1617–1682; *Christ Healing the Paralytic at the Pool of Bethesda*, 1667–1670; National Gallery, London

¹¹ I say unto thee, Arise, and take up thy bed, and go thy way into thine house.

¹² And immediately he arose, took up the bed, and went forth before them all; insomuch that they were all amazed, and glorified God, saying, We never saw it on this fashion.

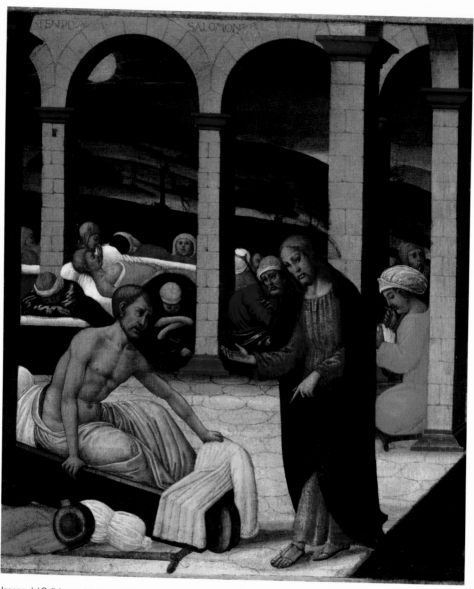

Jacopo del Sellaio, ca. 1441–1493; *The Pool of Bethesda*, 15th century; Pinacoteca Comunale, Castiglion Fiorentino, Tuscany

nd it came to pass on a certain day, as he was teaching, that there were Pharisees and doctors of the law sitting by, which were come out of every town of Galilee, and Judaea, and Jerusalem: and the power of the Lord was *present* to heal them.

18 And, behold, men brought in a bed a man which was taken with a palsy: and they sought *means* to bring him in, and to lay *him* before him.

19 And when they could not find by what *way* they might bring him in because of the multitude, they went upon the housetop, and let him down through the tiling with *his* couch into the midst before Jesus.

20 And when he saw their faith, he said unto him, Man, thy sins are forgiven thee.

21 And the scribes and the Pharisees began to reason, saying, Who is this which speaketh blasphemies? Who can forgive sins, but God alone?

22 But when Jesus perceived their thoughts, he answering said unto them, What reason ye in your hearts?

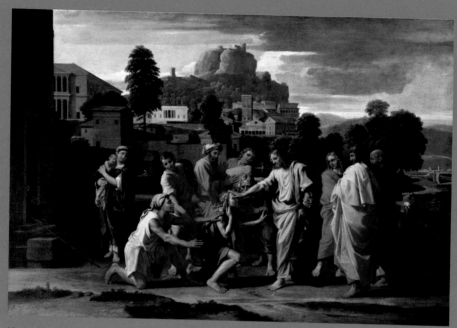

Nicolas Poussin, 1594–1665; *Christ Healing the Blind*, 1650; Louvre, Paris

HEALING THE BLIND MAN

Matthew 9:27–31

nd when Jesus departed thence, two blind men followed him, crying, and saying, *Thou* Son of David, have mercy on us.

²⁸ And when he was come into the house, the blind men came to him: and Jesus saith unto them, Believe ye that I am able to do this? They said unto him, Yea, Lord.

²⁹ Then touched he their eyes, saying, According to your faith be it unto you.

³⁰ And their eyes were opened; and Jesus straitly charged them, saying, See *that* no man know *it*.

³¹ But they, when they were departed, spread abroad his fame in all that country.

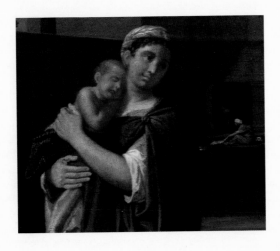

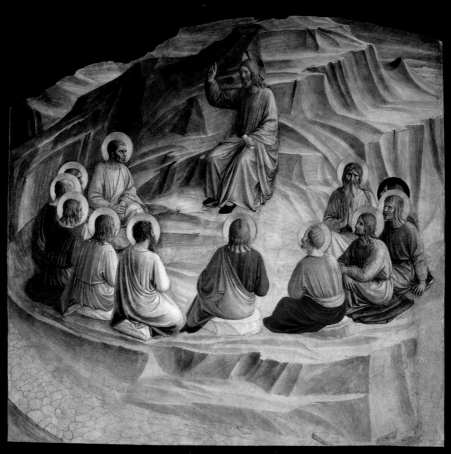

Fra Angelico (Guido di Pietro) ca. 1395–1455; *The Sermon on the Mount*, 1438–1466; San Marco Convent, Florence

SERMON ON THE MOUNT

Matthew 5–7

nd seeing the multitudes, he went up into a mountain: and when he was set, his disciples came unto him:

² And he opened his mouth, and taught them, saying,

³ Blessed *are* the poor in spirit: for theirs is the kingdom of heaven.

⁴ Blessed *are* they that mourn: for they shall be comforted.

⁵ Blessed *are* the meek: for they shall inherit the earth.

⁶ Blessed *are* they which do hunger and thirst after righteousness: for they shall be filled.

⁷ Blessed *are* the merciful: for they shall obtain mercy.

⁸ Blessed *are* the pure in heart: for they shall see God.

⁹ Blessed *are* the peacemakers: for they shall be called the children of God.

¹⁰ Blessed *are* they which are persecuted for righteousness' sake: for theirs is the kingdom of heaven.

¹¹ Blessed are ye, when *men* shall revile you, and persecute *you*, and shall say all manner of evil against you falsely, for my sake.

¹² Rejoice, and be exceeding glad: for great *is* your reward in heaven: for so persecuted they the prophets which were before you.

¹³ Ye are the salt of the earth: but if the salt have lost his savour, wherewith shall it be salted? it is thenceforth good for nothing, but to be cast out, and to be trodden under foot of men.

¹⁴ Ye are the light of the world. A city that is set on an hill cannot be hid.

¹⁵ Neither do men light a candle, and put it under a bushel, but on a candlestick; and it giveth light unto all that are in the house.

¹⁶ Let your light so shine before men, that they may see your good works, and glorify your Father which is in heaven.

¹⁷ Think not that I am come to destroy the law, or the prophets: I am not come to destroy, but to fulfil.

¹⁸ For verily I say unto you, Till heaven and earth pass, one jot or one tittle shall in no wise pass from the law, till all be fulfilled.

¹⁹ Whosoever therefore shall break one of these least commandments, and shall teach men so, he shall be called the least in the kingdom of heaven: but whosoever shall do and teach *them*, the same shall be called great in the kingdom of heaven.

²⁰ For I say unto you, That except your righteousness shall exceed *the righteousness* of the scribes and Pharisees, ye shall in no case enter into the kingdom of heaven.

²¹ Ye have heard that it was said by them of old time, Thou shalt not kill; and whosoever shall kill shall be in danger of the judgment:

²² But I say unto you, That whosoever is angry with his brother without a cause shall be in danger of the judgment: and whosoever shall say to his brother, Raca, shall be in danger of the council: but whosoever shall say, Thou fool, shall be in danger of hell fire.

²³ Therefore if thou bring thy gift to the altar, and there rememberest that thy brother hath ought against thee;

²⁴ Leave there thy gift before the altar, and go thy way; first be reconciled to thy brother, and then come and offer thy gift.

²⁵ Agree with thine adversary quickly, whiles thou art in the way with him; lest at any time the adversary deliver thee to the judge, and the judge deliver thee to the officer, and thou be cast into prison.

²⁶ Verily I say unto thee, Thou shalt by no means come out thence, till thou hast paid the uttermost farthing.

²⁷ Ye have heard that it was said by them of old time, Thou shalt not commit adultery:

²⁸ But I say unto you, That whosoever looketh on a woman to lust after her hath committed adultery with her already in his heart.

²⁹ And if thy right eye offend thee, pluck it out, and cast *it* from thee: for it is profitable for thee that one of thy members should perish, and not *that* thy whole body should be cast into hell.

³⁰ And if thy right hand offend thee, cut it off, and cast *it* from thee: for it is profitable for thee that one of thy members should perish, and not *that* thy whole body should be cast into hell.

³¹ It hath been said, Whosoever shall put away his wife, let him give her a writing of divorcement:

³² But I say unto you, That whosoever shall put away his wife, saving for the cause of fornication, causeth her to commit adultery: and whosoever shall marry her that is divorced committeth adultery.

³³ Again, ye have heard that it hath been said by them of old time, Thou shalt not forswear thyself, but shalt perform unto the Lord thine oaths:

³⁴ But I say unto you, Swear not at all; neither by heaven; for it is God's throne:

³⁵ Nor by the earth; for it is his footstool: neither by Jerusalem; for it is the city of the great King.

³⁶ Neither shalt thou swear by thy head, because thou canst not make one hair white or black.

³⁷ But let your communication be, Yea, yea; Nay, nay: for whatsoever is more than these cometh of evil.

³⁸ Ye have heard that it hath been said, An eye for an eye, and a tooth for a tooth:

³⁹ But I say unto you, That ye resist not evil: but whosoever shall smite thee on thy right cheek, turn to him the other also.

⁴⁰ And if any man will sue thee at the law, and take away thy coat, let him have *thy* cloke also.

⁴¹ And whosoever shall compel thee to go a mile, go with him twain.

⁴² Give to him that asketh thee, and from him that would borrow of thee turn not thou away.

⁴³ Ye have heard that it hath been said, Thou shalt love thy neighbour, and hate thine enemy.

⁴⁴ But I say unto you, Love your enemies, bless them that curse you, do good to them that hate you, and pray for them which despitefully use you, and persecute you;

⁴⁵ That ye may be the children of your Father which is in heaven: for he maketh his sun to rise on the evil and on the good, and sendeth rain on the just and on the unjust.

⁴⁶ For if ye love them which love you, what reward have ye? do not even the publicans the same?

⁴⁷ And if ye salute your brethren only, what do ye more *than others*? do not even the publicans so?

⁴⁸ Be ye therefore perfect, even as your Father which is in heaven is perfect.

¹ Take heed that ye do not your alms before men, to be seen of them: otherwise ye have no reward of your Father which is in heaven.

² Therefore when thou doest *thine* alms, do not sound a trumpet before thee, as the hypocrites do in the synagogues and in the streets, that they may have glory of men. Verily I say unto you, They have their reward.

³ But when thou doest alms, let not thy left hand know what thy right hand doeth:

⁴ That thine alms may be in secret: and thy Father which seeth in secret himself shall reward thee openly.

⁵ And when thou prayest, thou shalt not be as the hypocrites *are*: for they love to pray standing in the synagogues and in the corners of the streets, that they may be seen of men. Verily I say unto you, They have their reward.

⁶ But thou, when thou prayest, enter into thy closet, and when thou hast shut thy door, pray to thy Father which is in secret; and thy Father which seeth in secret shall reward thee openly.

⁷ But when ye pray, use not vain repetitions, as the heathen *do*: for they think that they shall be heard for their much speaking.

⁸ Be not ye therefore like unto them: for your Father knoweth what things ye have need of, before ye ask him.

⁹ After this manner therefore pray ye: Our Father which art in heaven, Hallowed be thy name.

¹⁰ Thy kingdom come. Thy will be done in earth, as *it is* in heaven.

¹¹ Give us this day our daily bread.

¹² And forgive us our debts, as we forgive our debtors.

¹³ And lead us not into temptation, but deliver us from evil: For thine is the kingdom, and the power, and the glory, for ever. Amen.

¹⁴ For if ye forgive men their trespasses, your heavenly Father will also forgive you:

¹⁵ But if ye forgive not men their trespasses, neither will your Father forgive your trespasses.

¹⁶ Moreover when ye fast, be not, as the hypocrites, of a sad countenance: for they disfigure their faces, that they may appear unto men to fast. Verily I say unto you, They have their reward.

¹⁷ But thou, when thou fastest, anoint thine head, and wash thy face;

¹⁸ That thou appear not unto men to fast, but unto thy Father which is in secret: and thy Father, which seeth in secret, shall reward thee openly.

¹⁹ Lay not up for yourselves treasures upon earth, where moth and rust doth corrupt, and where thieves break through and steal:

²⁰ But lay up for yourselves treasures in heaven, where neither moth nor rust doth corrupt, and where thieves do not break through nor steal:

²¹ For where your treasure is, there will your heart be also.

²² The light of the body is the eye: if therefore thine eye be single, thy whole body shall be full of light.

²³ But if thine eye be evil, thy whole body shall be full of darkness. If therefore the light that is in thee be darkness, how great *is* that darkness!

²⁴ No man can serve two masters: for either he will hate the one, and love the other; or else he will hold to the one, and despise the other. Ye cannot serve God and mammon.

²⁵ Therefore I say unto you, Take no thought for your life, what ye shall eat, or what ye shall drink; nor yet for your body, what ye shall put on. Is not the life more than meat, and the body than raiment?

²⁶ Behold the fowls of the air:

for they sow not, neither do they reap, nor gather into barns; yet your heavenly Father feedeth them. Are ye not much better than they?

²⁷ Which of you by taking thought can add one cubit unto his stature?

²⁸ And why take ye thought for raiment? Consider the lilies of the field, how they grow; they toil not, neither do they spin:

²⁹ And yet I say unto you, That even Solomon in all his glory was not arrayed like one of these.

³⁰ Wherefore, if God so clothe the grass of the field, which to day is, and to morrow is cast into the oven, *shall he* not much more *clothe* you, O ye of little faith?

³¹ Therefore take no thought, saying, What shall we eat? or, What shall we drink? or, Wherewithal shall we be clothed?

³² (For after all these things do the Gentiles seek:) for your heavenly Father knoweth that ye have need of all these things.

³³ But seek ye first the kingdom of God, and his righteousness; and all these things shall be added unto you.

³⁴ Take therefore no thought for the morrow: for the morrow shall take thought for the things of itself. Sufficient unto the day *is* the evil thereof.

¹ Judge not, that ye be not judged.

² For with what judgment ye judge, ye shall be judged: and with what measure ye mete, it shall be measured to you again.

³ And why beholdest thou the mote that is in thy brother's eye, but considerest not the beam that is in thine own eye?

⁴ Or how wilt thou say to thy brother, Let me pull out the mote out of thine eye; and, behold, a beam *is* in thine own eye?

⁵ Thou hypocrite, first cast out the beam out of thine own eye; and then shalt thou see clearly to cast out the mote out of thy brother's eye.

⁶ Give not that which is holy unto the dogs, neither cast ye your pearls before swine, lest they trample them under their feet, and turn again and rend you.

⁷ Ask, and it shall be given you; seek, and ye shall find; knock, and it shall be opened unto you:

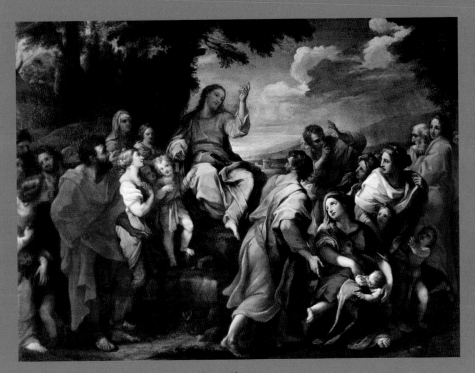

Hendrik Krock, 1677–1738; *The Sermon on the Mount*; 18th century

⁸ For every one that asketh receiveth; and he that seeketh findeth; and to him that knocketh it shall be opened.

⁹ Or what man is there of you, whom if his son ask bread, will he give him a stone?

¹⁰ Or if he ask a fish, will he give him a serpent?

¹¹ If ye then, being evil, know how to give good gifts unto your children, how much more shall your Father which is in heaven give good things to them that ask him?

¹² Therefore all things whatsoever ye would that men should do to you, do ye even so to them: for this is the law and the prophets.

¹³ Enter ye in at the strait gate: for wide *is* the gate, and broad *is* the way, that leadeth to destruction, and many there be which go in thereat:

¹⁴ Because strait *is* the gate, and narrow *is* the way, which leadeth unto life, and few there be that find it.

¹⁵ Beware of false prophets, which come to you in sheep's clothing, but inwardly they are ravening wolves.

¹⁶ Ye shall know them by their

fruits. Do men gather grapes of thorns, or figs of thistles?

17 Even so every good tree bringeth forth good fruit; but a corrupt tree bringeth forth evil fruit.

18 A good tree cannot bring forth evil fruit, neither *can* a corrupt tree bring forth good fruit.

19 Every tree that bringeth not forth good fruit is hewn down, and cast into the fire.

20 Wherefore by their fruits ye shall know them.

21 Not every one that saith unto me, Lord, Lord, shall enter into the kingdom of heaven; but he that doeth the will of my Father which is in heaven.

22 Many will say to me in that day, Lord, Lord, have we not prophesied in thy name? and in thy name have cast out devils? and in thy name done many wonderful works?

23 And then will I profess unto them, I never knew you: depart from me, ye that work iniquity.

24 Therefore whosoever heareth these sayings of mine, and doeth them, I will liken him unto a wise man, which built his house upon a rock:

25 And the rain descended, and the floods came, and the winds blew, and beat upon that house; and it fell not: for it was founded upon a rock.

26 And every one that heareth these sayings of mine, and doeth them not, shall be likened unto a foolish man, which built his house upon the sand:

27 And the rain descended, and the floods came, and the winds blew, and beat upon that house; and it fell: and great was the fall of it.

28 And it came to pass, when Jesus had ended these sayings, the people were astonished at his doctrine:

29 For he taught them as *one* having authority, and not as the scribes.

DEATH OF JOHN THE BAPTIST

Matthew 14:1–13

t that time Herod the tetrarch heard of the fame of Jesus,

2 And said unto his servants, This is John the Baptist; he is risen from the dead; and therefore mighty works do shew forth themselves in him.

3 For Herod had laid hold on John, and bound him, and put *him* in prison for Herodias' sake, his brother Philip's wife.

4 For John said unto him, It is not lawful for thee to have her.

5 And when he would have put him to death, he feared the multitude, because they counted him as a prophet.

6 But when Herod's birthday was kept, the daughter of Herodias danced before them, and pleased Herod.

7 Whereupon he promised with an oath to give her whatsoever she would ask.

8 And she, being before instructed of her mother, said, Give me here John Baptist's head in a charger.

9 And the king was sorry: nevertheless for the oath's sake, and them which sat with him at meat, he commanded *it* to be given *her*.

10 And he sent, and beheaded John in the prison.

11 And his head was brought in a charger, and given to the damsel: and she brought *it* to her mother.

12 And his disciples came, and took up the body, and buried it, and went and told Jesus.

13 When Jesus heard *of it*, he departed thence by ship into a desert place apart: and when the people had heard *thereof*, they followed him on foot out of the cities.

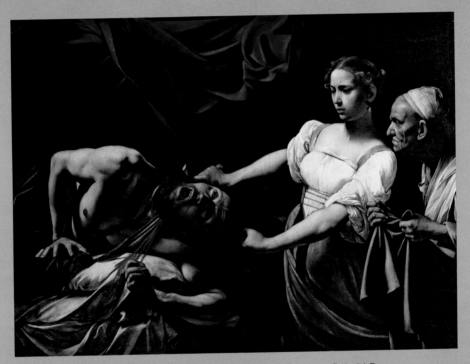

Caravaggio (Michelangelo Merisi), 1571–1610; *Judith and Holofernes*, 1599; Palazzo Barberini, Rome

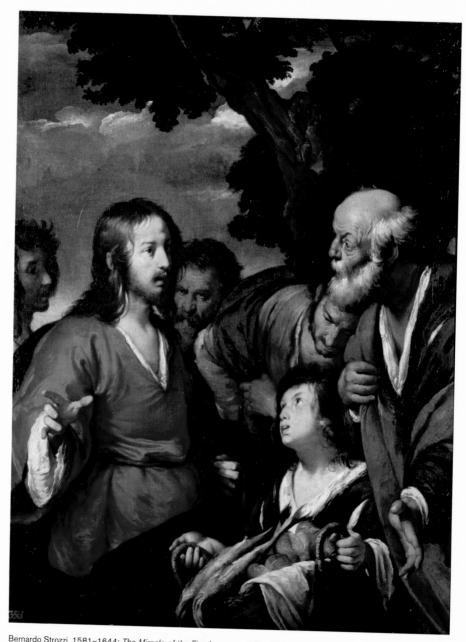

Bernardo Strozzi, 1581–1644; *The Miracle of the Five Loaves and Two Fishes*, after 1630; State A. Pushkin Museum of Fine Arts, Moscow

MIRACLE OF LOAVES AND FISHES

Luke 9:10–17

nd the apostles, when they were returned, told him all that they had done. And he took them, and went aside privately into a desert place belonging to the city called Bethsaida.

¹¹ And the people, when they knew *it*, followed him: and he received them, and spake unto them of the kingdom of God, and healed them that had need of healing.

¹² And when the day began to wear away, then came the twelve, and said unto him, Send the multitude away, that they may go into the towns and country round about, and lodge, and get victuals: for we are here in a desert place.

¹³ But he said unto them, Give ye them to eat. And they said, We have no more but five loaves and two fishes; except we should go and buy meat for all this people.

¹⁴ For they were about five thousand men. And he said to his disciples, Make them sit down by fifties in a company.

¹⁵ And they did so, and made them all sit down.

¹⁶ Then he took the five loaves and the two fishes, and looking up to heaven, he blessed them, and brake, and gave to the disciples to set before the multitude.

¹⁷ And they did eat, and were all filled: and there was taken up of fragments that remained to them twelve baskets.

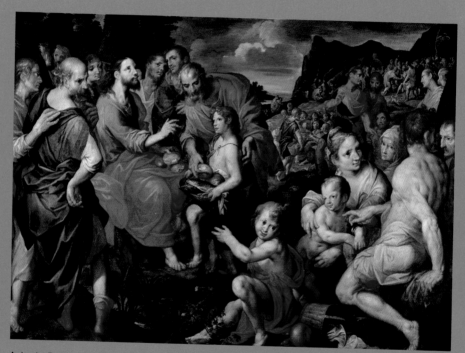

Ambrosius Francken the Elder, 1544–1618; *The Feeding of the Five Thousand*, 17th century; Musee des Beaux–Arts, Arras, France

hen Jesus heard *of it*, he departed thence by ship into a desert place apart: and when the people had heard *thereof*, they followed him on foot out of the cities.

¹⁴ And Jesus went forth, and saw a great multitude, and was moved with compassion toward them, and he healed their sick.

¹⁵ And when it was evening, his disciples came to him, saying, This is a desert place, and the time is now past; send the multitude away, that they may go into the villages, and buy themselves victuals.

¹⁶ But Jesus said unto them, They need not depart; give ye them to eat.

¹⁷ And they say unto him, We have here but five loaves, and two fishes.

¹⁸ He said, Bring them hither to me.

¹⁹ And he commanded the multitude to sit down on the grass, and took the five loaves, and the two fishes, and looking up to heaven, he blessed, and brake, and gave the loaves to *his* disciples, and the disciples to the multitude.

²⁰ And they did all eat, and were filled: and they took up of the fragments that remained twelve baskets full.

²¹ And they that had eaten were about five thousand men, beside women and children.

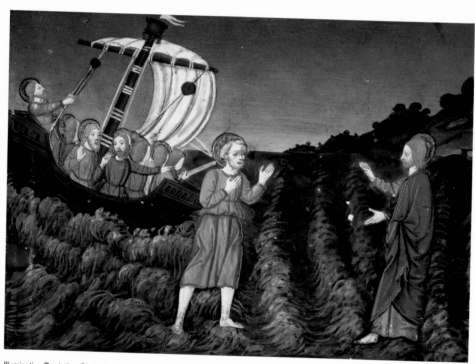

Illumination Depicting Christ Convincing Peter to Walk on the Water, in the Codex De Predis (c.65r), 15th century; Royal Library in Turin

CHRIST WALKING ON WATER

John 6:15–21

hen Jesus therefore perceived that they would come and take him by force, to make him a king, he departed again into a mountain himself alone.

¹⁶ And when even was *now* come, his disciples went down unto the sea,

¹⁷ And entered into a ship, and went over the sea toward Capernaum. And it was now dark, and Jesus was not come to them.

¹⁸ And the sea arose by reason of a great wind that blew.

¹⁹ So when they had rowed about five and twenty or thirty furlongs, they see Jesus walking on the sea, and drawing nigh unto the ship: and they were afraid.

²⁰ But he saith unto them, It is I; be not afraid.

²¹ Then they willingly received him into the ship: and immediately the ship was at the land whither they went.

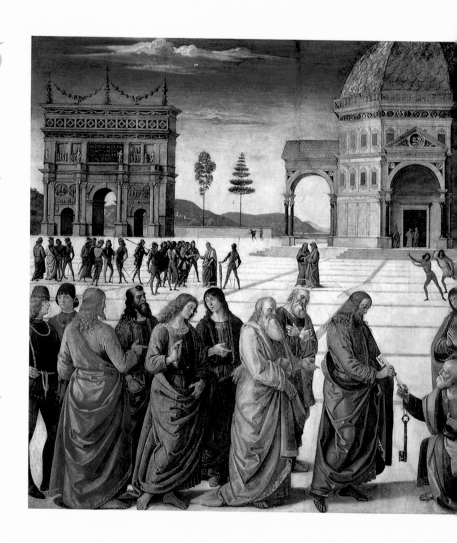

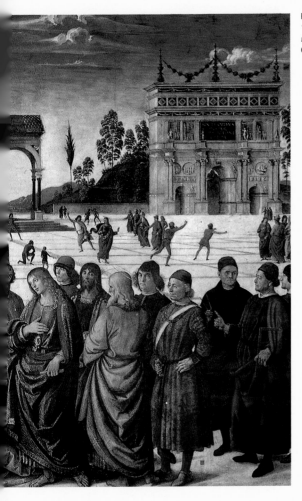

Perugino (Pietro Perugino), ca.
1450–1523; *Delivery of the Keys
to Saint Peter*, 1481; Sistine
Chapel, Vatican

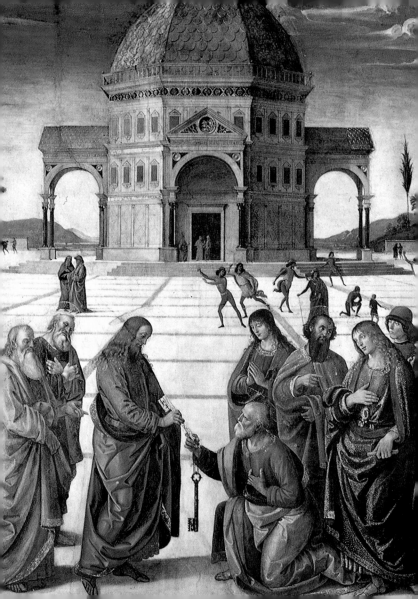

PETER'S CONFESSION

Matthew 16:13–23

hen Jesus came into the coasts of Caesarea Philippi, he asked his disciples, saying, Whom do men say that I the Son of man am?

¹⁴ And they said, Some *say that thou art* John the Baptist: some, Elias; and others, Jeremias, or one of the prophets.

¹⁵ He saith unto them, But whom say ye that I am?

¹⁶ And Simon Peter answered and said, Thou art the Christ, the Son of the living God.

¹⁷ And Jesus answered and said unto him, Blessed art thou, Simon Barjona: for flesh and blood hath not revealed *it* unto thee, but my Father which is in heaven.

¹⁸ And I say also unto thee, That thou art Peter, and upon this rock I will build my church; and the gates of hell shall not prevail against it.

¹⁹ And I will give unto thee the keys of the kingdom of heaven: and whatsoever thou shalt bind on earth shall be bound in heaven: and whatsoever thou shalt loose on earth shall be loosed in heaven.

²⁰ Then charged he his disciples that they should tell no man that he was Jesus the Christ.

²¹ From that time forth began Jesus to shew unto his disciples, how that he must go unto Jerusalem, and suffer many things of the elders and chief priests and scribes, and be killed, and be raised again the third day.

²² Then Peter took him, and began to rebuke him, saying, Be it far from thee, Lord: this shall not be unto thee.

²³ But he turned, and said unto Peter, Get thee behind me, Satan: thou art an offence unto me: for thou savourest not the things that be of God, but those that be of men.

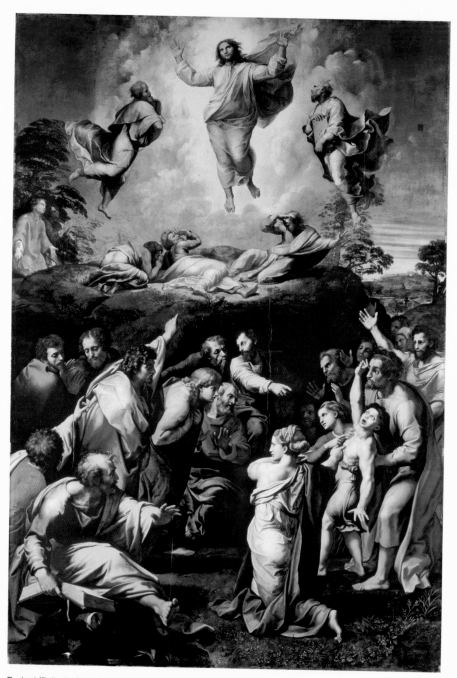

Raphael (Raffaello Sanzio), 1483–1520, *The Transfiguration of Christ*, 1516–1520; Pinacoteca Vaticana, Rome

THE TRANSFIGURATION

Mark 9:2–8

nd after six days Jesus taketh *with him* Peter, and James, and John, and leadeth them up into an high mountain apart by themselves: and he was transfigured before them.

³ And his raiment became shining, exceeding white as snow; so as no fuller on earth can white them.

⁴ And there appeared unto them Elias with Moses: and they were talking with Jesus.

⁵ And Peter answered and said to Jesus, Master, it is good for us to be here: and let us make three tabernacles; one for thee, and one for Moses, and one for Elias.

⁶ For he wist not what to say; for they were sore afraid.

⁷ And there was a cloud that overshadowed them: and a voice came out of the cloud, saying, This is my beloved Son: hear him.

⁸ And suddenly, when they had looked round about, they saw no man any more, save Jesus only with themselves.

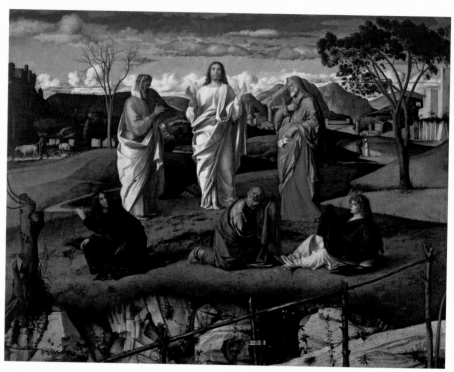

Giovanni Bellini, 1431/36–1516, *Transfiguration of Christ*, 1478–1479; Capodimonte National Museum and Galleries, Naples

or whosoever shall be ashamed of me and of my words, of him shall the Son of man be ashamed, when he shall come in his own glory, and *in his* Father's, and of the holy angels.

27 But I tell you of a truth, there be some standing here, which shall not taste of death, till they see the kingdom of God.

28 And it came to pass about an eight days after these sayings, he took Peter and John and James, and went up into a mountain to pray.

29 And as he prayed, the fashion of his countenance was altered, and his raiment *was* white *and* glistering.

30 And, behold, there talked with him two men, which were Moses and Elias:

31 Who appeared in glory, and spake of his decease which he should accomplish at Jerusalem.

32 But Peter and they that were with him were heavy with sleep: and when they were awake, they saw his glory, and the two men that stood with him.

33 And it came to pass, as they departed from him, Peter said unto Jesus, Master, it is good for us to be here: and let us make three tabernacles; one for thee, and one for Moses, and one for Elias: not knowing what he said.

34 While he thus spake, there came a cloud, and overshadowed them: and they feared as they entered into the cloud.

35 And there came a voice out of the cloud, saying, This is my beloved Son: hear him.

36 And when the voice was past, Jesus was found alone. And they kept *it* close, and told no man in those days any of those things which they had seen.

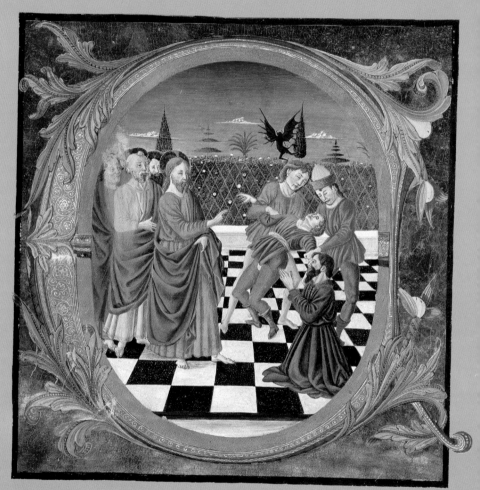

Francesco Rosselli, Italian, 1445–before 1513; *Christ Heals the Demoniac (Exultate)*, 15th century; Santa Maria Assunta Cathedral, Siena

HEALING OF THE DEMON–POSSESSED BOY

Matthew 17:14–21

nd when they were come to the multitude, there came to him a *certain* man, kneeling down to him, and saying,

¹⁵ Lord, have mercy on my son: for he is lunatick, and sore vexed: for oft times he falleth into the fire, and oft into the water.

¹⁶ And I brought him to thy disciples, and they could not cure him.

¹⁷ Then Jesus answered and said, O faithless and perverse generation, how long shall I be with you? how long shall I suffer you? bring him hither to me.

¹⁸ And Jesus rebuked the devil; and he departed out of him: and the child was cured from that very hour.

¹⁹ Then came the disciples to Jesus apart, and said, Why could not we cast him out?

²⁰ And Jesus said unto them, Because of your unbelief: for verily I say unto you, If ye have faith as a grain of mustard seed, ye shall say unto this mountain, Remove hence to yonder place; and it shall remove; and nothing shall be impossible unto you.

²¹ Howbeit this kind goeth not out but by prayer and fasting.

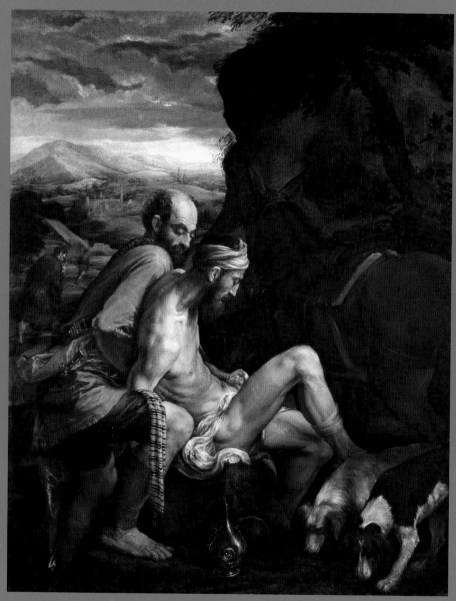

Jacopo Bassano, ca. 1510–1592; *The Good Samaritan*, ca. 1562–1563; National Gallery, London

THE GOOD SAMARITAN

Luke 10:29–37

ut he, willing to justify himself, said unto Jesus, And who is my neighbour?

³⁰ And Jesus answering said, A certain *man* went down from Jerusalem to Jericho, and fell among thieves, which stripped him of his raiment, and wounded *him*, and departed, leaving *him* half dead.

³¹ And by chance there came down a certain priest that way: and when he saw him, he passed by on the other side.

³² And likewise a Levite, when he was at the place, came and looked *on him*, and passed by on the other side.

³³ But a certain Samaritan, as he journeyed, came where he was: and when he saw him, he had compassion *on him*,

³⁴ And went to *him*, and bound up his wounds, pouring in oil and wine, and set him on his own beast, and brought him to an inn, and took care of him.

³⁵ And on the morrow when he departed, he took out two pence, and gave *them* to the host, and said unto him, Take care of him; and whatsoever thou spendest more, when I come again, I will repay thee.

³⁶ Which now of these three, thinkest thou, was neighbour unto him that fell among the thieves?

³⁷ And he said, He that shewed mercy on him. Then said Jesus unto him, Go, and do thou likewise.

CHRIST IN THE HOUSE OF MARY AND MARTHA

Luke 10:38–42

ow it came to pass, as they went, that he entered into a certain village: and a certain woman named Martha received him into her house.

³⁹ And she had a sister called Mary, which also sat at Jesus' feet, and heard his word.

⁴⁰ But Martha was cumbered about much serving, and came to him, and said, Lord, dost thou not care that my sister hath left me to serve alone? bid her therefore that she help me.

⁴¹ And Jesus answered and said unto her, Martha, Martha, thou art careful and troubled about many things:

⁴² But one thing is needful: and Mary hath chosen that good part, which shall not be taken away from her.

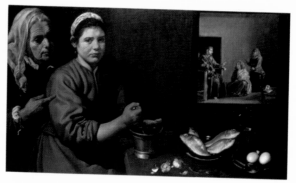

Diego Velázquez, 1599–1660; *Christ in the House of Mary and Martha*, ca. 1618–1622; National Gallery, London

SUPPER IN THE HOUSE OF SIMON

Luke 7:36–50

ne of the Pharisees asked Jesus to eat with him, so Jesus went into the Pharisee's house and sat at the table.

³⁷ A sinful woman in the town learned that Jesus was eating at the Pharisee's house. So she brought an alabaster jar of perfume

³⁸ and stood behind Jesus at his feet, crying. She began to wash his feet with her tears, and she dried them with her hair, kissing them many times and rubbing them with the perfume.

³⁹ When the Pharisee who asked Jesus to come to his house saw this, he thought to himself, "If Jesus were a prophet, he would know that the woman touching him is a sinner!"

⁴⁰ Jesus said to the Pharisee, "Simon, I have something to say to you." Simon said, "Teacher, tell me."

⁴¹ Jesus said, "Two people owed money to the same banker. One owed five hundred coins and the other owed fifty.

⁴² They had no money to pay what they owed, but the banker told both of them they did not have to pay him. Which person will love the banker more?"

⁴³ Simon, the Pharisee, answered, "I think it would be the one who owed him the most money."

Jesus said to Simon, "You are right."

⁴⁴ Then Jesus turned toward the woman and said to Simon, "Do you see this woman? When I came into your house, you gave me no water for my feet, but she washed my feet with her tears and dried them with her hair.

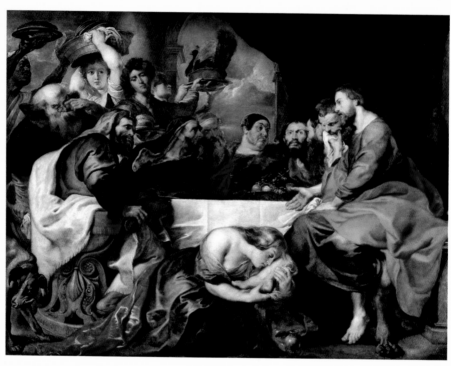

Peter Paul Rubens, 1577–1640; *Feast in the House of Simon the Pharisee*, 1618–1620; State Hermitage, St. Petersburg

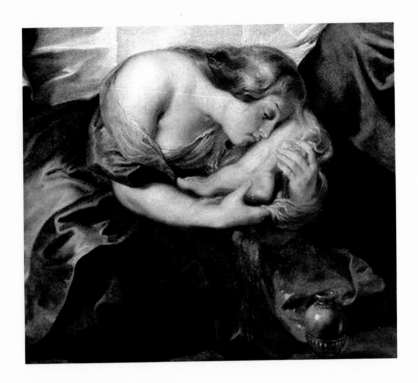

⁴⁵ You gave me no kiss of greeting, but she has been kissing my feet since I came in.

⁴⁶ You did not put oil on my head, but she poured perfume on my feet.

⁴⁷ I tell you that her many sins are forgiven, so she showed great love. But the person who is forgiven only a little will love only a little."

⁴⁸ Then Jesus said to her, "Your sins are forgiven."

⁴⁹ The people sitting at the table began to say among themselves, "Who is this who even forgives sins?"

⁵⁰ Jesus said to the woman, "Because you believed, you are saved from your sins. Go in peace."

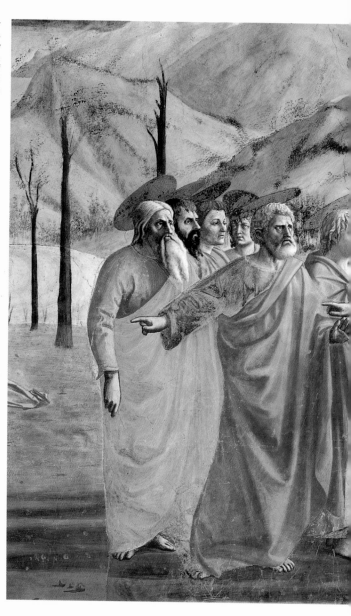

Masaccio (Tommaso di Giovanni), 1401–1428; *The Tribute Money*, 1425; Church of Santa Maria del Carmine, Florence

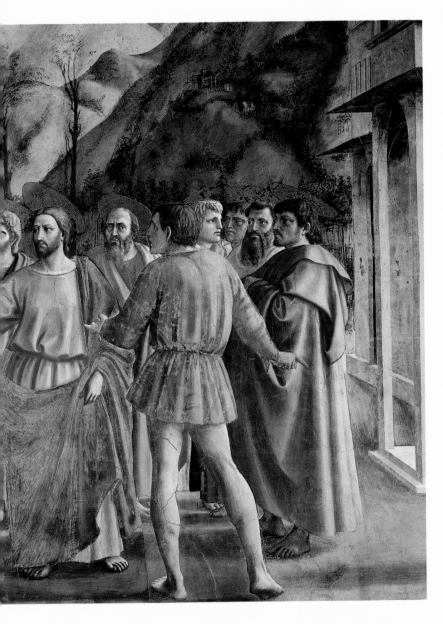

THE TRIBUTE MONEY

(Matthew 17:24–27)

fter Jesus and his disciples arrived in Capernaum, the collectors of the two–drachma temple tax came to Peter and asked, "Doesn't your teacher pay the temple tax?"

25 "Yes, he does," he replied. When Peter came into the house, Jesus was the first to speak. "What do you think, Simon?" he asked. "From whom do the kings of the earth collect duty and taxes—from their own

children or from others?"

26 "From others," Peter answered.

"Then the children are exempt," Jesus said to him.

27 "But so that we may not cause offense, go to the lake and throw out your line. Take the first fish you catch; open its mouth and you will find a four–drachma coin. Take it and give it to them for my tax and yours."

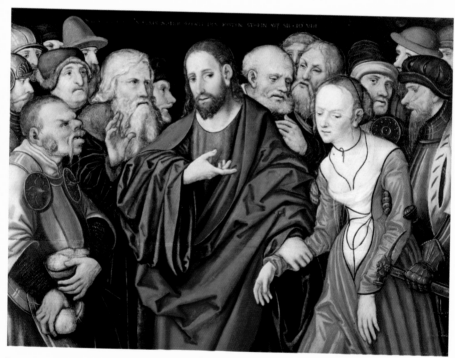

Lucas Cranach the Elder, 1472–1553; *Jesus and the Woman Taken in Adultery*, 1525–1550; Capodimonte National Museum and Galleries, Naples

THE ADULTEROUS WOMAN

John 8:1–31

esus went unto the mount of Olives.

² And early in the morning he came again into the temple, and all the people came unto him; and he sat down, and taught them.

³ And the scribes and Pharisees brought unto him a woman taken in adultery; and when they had set her in the midst,

⁴ They say unto him, Master, this woman was taken in adultery, in the very act.

⁵ Now Moses in the law commanded us, that such should be stoned: but what sayest thou?

⁶ This they said, tempting him, that they might have to accuse him. But Jesus stooped down, and with *his* finger wrote on the ground, *as though he heard them not.*

⁷ So when they continued asking him, he lifted up himself, and said unto them, He that is without sin among you, let him first cast a stone at her.

⁸ And again he stooped down, and wrote on the ground.

⁹ And they which heard *it,* being convicted by *their own* conscience, went out one by one, beginning at the eldest, *even* unto the last: and Jesus was left alone, and the woman standing in the midst.

¹⁰ When Jesus had lifted up himself, and saw none but the woman, he said unto her, Woman, where are those thine accusers? hath no man condemned thee?

¹¹ She said, No man, Lord. And Jesus said unto her, Neither do I condemn thee: go, and sin no more.

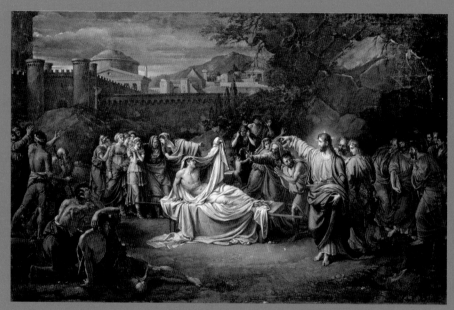

Jean Baptiste Joseph de Bay, 1762–1834; *Christ Resurrects the Widow of Naim's Son*, 1806–1816; St. Luke's Academy Gallery, Rome

JESUS RESURRECTS THE SON OF THE WIDOW OF NAIN

Luke 7:11–17

oon afterward he went to a town called Nain, and his disciples and a great crowd went with him.

¹² As he drew near to the gate of the town, behold, a man who had died was being carried out, the only son of his mother, and she was a widow, and a considerable crowd from the town was with her.

¹³ And when the Lord saw her, he had compassion on her and said to her, "Do not weep."

¹⁴ Then he came up and touched the bier, and the bearers stood still. And he said, "Young man, I say to you, arise."

¹⁵ And the dead man sat up and began to speak, and Jesus gave him to his mother.

¹⁶ Fear seized them all, and they glorified God, saying, "A great prophet has arisen among us!" and "God has visited his people!"

¹⁷ And this report about him spread through the whole of Judea and all the surrounding country.

LAZARUS

Luke 11:1–44

ow a certain *man* was sick, *named* Lazarus, of Bethany, the town of Mary and her sister Martha.

² (It was *that* Mary which anointed the Lord with ointment, and wiped his feet with her hair, whose brother Lazarus was sick.)

³ Therefore his sisters sent unto him, saying, Lord, behold, he whom thou lovest is sick.

⁴ When Jesus heard *that*, he said, This sickness is not unto death, but for the glory of God, that the Son of God might be glorified thereby.

⁵ Now Jesus loved Martha, and her sister, and Lazarus.

⁶ When he had heard therefore that he was sick, he abode two days still in the same place where he was.

⁷ Then after that saith he to *his* disciples, Let us go into Judaea again.

⁸ *His* disciples say unto him, Master, the Jews of late sought to stone thee; and goest thou thither again?

⁹ Jesus answered, Are there not twelve hours in the day? If any man walk in the day, he stumbleth not, because he seeth the light of this world.

¹⁰ But if a man walk in the night, he stumbleth, because there is no light in him.

¹¹ These things said he: and after that he saith unto them, Our friend Lazarus sleepeth; but I go, that I may awake him out of sleep.

¹² Then said his disciples, Lord, if he sleep, he shall do well.

¹³ Howbeit Jesus spake of his death: but they thought that he had spoken of taking of rest in sleep.

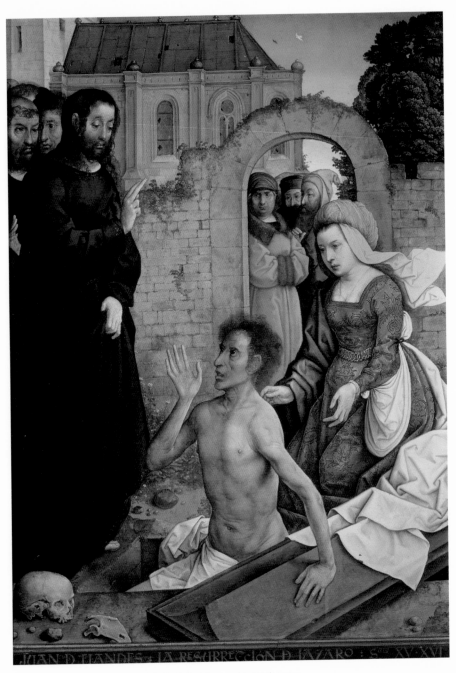

Juan de Flandes, South Netherlandish (active in Spain), second half 15th century

¹⁴ Then said Jesus unto them plainly, Lazarus is dead.

¹⁵ And I am glad for your sakes that I was not there, to the intent ye may believe; nevertheless let us go unto him.

¹⁶ Then said Thomas, which is called Didymus, unto his fellow-disciples, Let us also go, that we may die with him.

¹⁷ Then when Jesus came, he found that he had *lain* in the grave four days already.

¹⁸ Now Bethany was nigh unto Jerusalem, about fifteen furlongs off:

¹⁹ And many of the Jews came to Martha and Mary, to comfort them concerning their brother.

²⁰ Then Martha, as soon as she heard that Jesus was coming, went and met him: but Mary sat *still* in the house.

²¹ Then said Martha unto Jesus, Lord, if thou hadst been here, my brother had not died.

²² But I know, that even now, whatsoever thou wilt ask of God, God will give *it* thee.

²³ Jesus saith unto her, Thy brother shall rise again.

²⁴ Martha saith unto him, I know that he shall rise again in the resurrection at the last day.

²⁵ Jesus said unto her, I am the resurrection, and the life: he that believeth in me, though he were dead, yet shall he live:

²⁶ And whosoever liveth and believeth in me shall never die. Believest thou this?

²⁷ She saith unto him, Yea, Lord: I believe that thou art the Christ, the Son of God, which should come into the world.

²⁸ And when she had so said, she went her way, and called Mary her sister secretly, saying, The Master is come, and calleth for thee.

²⁹ As soon as she heard *that*, she arose quickly, and came unto him.

³⁰ Now Jesus was not yet come into the town, but was in that place where Martha met him.

³¹ The Jews then which were with her in the house, and comforted her, when they saw Mary, that she rose up hastily and went out, followed her, saying, She goeth unto the grave to weep there.

³² Then when Mary was come where Jesus was, and saw him, she fell down at his feet, saying unto him, Lord, if thou hadst

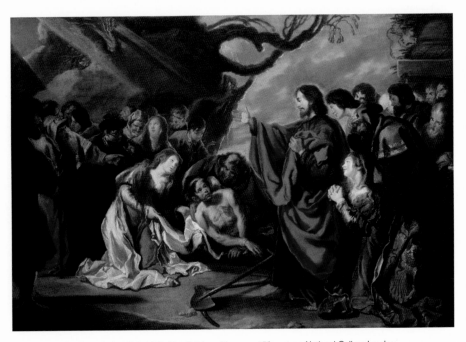

Simon de Vos (attributed to), 1603–1676; *The Raising of Lazarus*, 17th century; National Gallery, London

been here, my brother had not died.

³³ When Jesus therefore saw her weeping, and the Jews also weeping which came with her, he groaned in the spirit, and was troubled,

³⁴ And said, Where have ye laid him? They said unto him, Lord, come and see.

³⁵ Jesus wept.

³⁶ Then said the Jews, Behold how he loved him!

³⁷ And some of them said, Could not this man, which opened the eyes of the blind, have caused that even this man should not have died?

³⁸ Jesus therefore again groaning in himself cometh to the grave. It was a cave, and a stone lay upon it.

³⁹ Jesus said, Take ye away the stone. Martha, the sister of him that was dead, saith unto him, Lord, by this time he stinketh: for he hath been *dead* four days.

⁴⁰ Jesus saith unto her, Said I not unto thee, that, if thou wouldest believe, thou shouldest see the glory of God?

⁴¹ Then they took away the stone *from the place* where the dead was laid. And Jesus lifted up *his* eyes, and said, Father, I thank thee that thou hast heard me.

⁴² And I knew that thou hearest me always: but because of the people which stand by I said *it*, that they may believe that thou hast sent me.

⁴³ And when he thus had spoken, he cried with a loud voice, Lazarus, come forth.

⁴⁴ And he that was dead came forth, bound hand and foot with graveclothes: and his face was bound about with a napkin. Jesus saith unto them, Loose him, and let him go.

THE RETURN OF
THE PRODIGAL SON

Luke 15:11–31

A nd he said, A certain man had two sons:

¹² And the younger of them said to *his* father, Father, give me the portion of goods that falleth *to me.* And he divided unto them *his* living.

¹³ And not many days after the younger son gathered all together, and took his journey into a far country, and there wasted his substance with riotous living.

¹⁴ And when he had spent all, there arose a mighty famine in that land; and he began to be in want.

¹⁵ And he went and joined himself to a citizen of that country; and he sent him into his fields to feed swine.

¹⁶ And he would fain have filled his belly with the husks that the swine did eat: and no man gave unto him.

¹⁷ And when he came to himself, he said, How many hired servants of my father's have bread enough and to spare, and I perish with hunger!

¹⁸ I will arise and go to my father, and will say unto him, Father, I have sinned against heaven, and before thee,

¹⁹ And am no more worthy to be called thy son: make me as one of thy hired servants.

²⁰ And he arose, and came to his father. But when he was yet a great way off, his father saw him, and had compassion, and ran, and fell on his neck, and kissed him.

²¹ And the son said unto him, Father, I have sinned against heaven, and in thy sight, and am no more worthy to be called thy son.

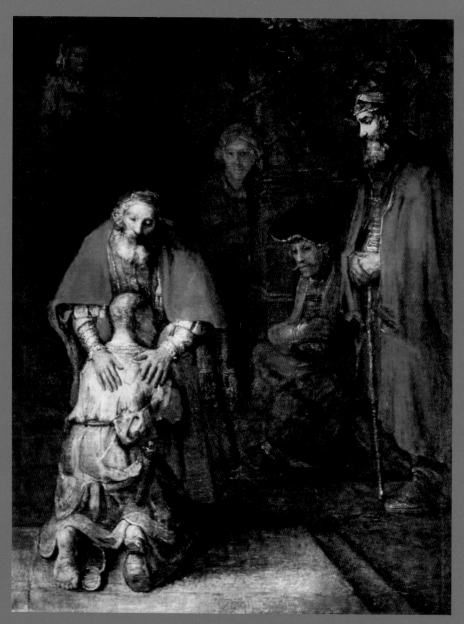

Rembrandt van Rijn, 1606–1669; *The Return of the Prodigal Son*, ca. 1668; Hermitage Museum, Saint Petersburg

²² But the father said to his servants, Bring forth the best robe, and put *it* on him; and put a ring on his hand, and shoes on *his* feet:

²³ And bring hither the fatted calf, and kill *it*; and let us eat, and be merry:

²⁴ For this my son was dead, and is alive again; he was lost, and is found. And they began to be merry.

²⁵ Now his elder son was in the field: and as he came and drew nigh to the house, he heard musick and dancing.

²⁶ And he called one of the servants, and asked what these things meant.

²⁷ And he said unto him, Thy brother is come; and thy father hath killed the fatted calf, because he hath received him safe and sound.

²⁸ And he was angry, and would not go in: therefore came his father out, and intreated him.

²⁹ And he answering said to *his* father, Lo, these many years do I serve thee, neither transgressed I at any time thy commandment: and yet thou never gavest me a kid, that I might make merry with my friends:

³⁰ But as soon as this thy son was come, which hath devoured thy living with harlots, thou hast killed for him the fatted calf.

³¹ And he said unto him, Son, thou art ever with me, and all that I have is thine.

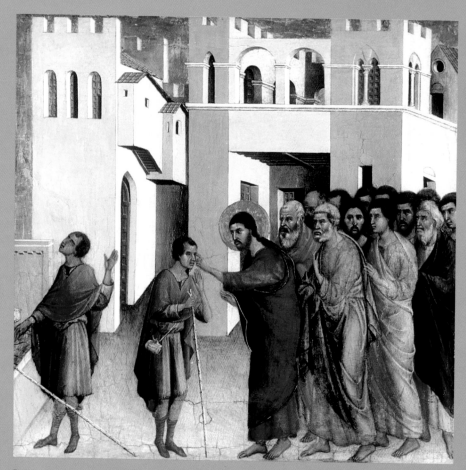

Duccio di Buoninsegna, 1255–1319; *Jesus Opens the Eyes of the Blind Man*, 1311; National Gallery, London

THE PARABLE
OF THE BLIND

Luke 6:39–49

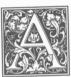nd he spake a parable unto them, Can the blind lead the blind? shall they not both fall into the ditch?

⁴⁰ The disciple is not above his master: but every one that is perfect shall be as his master.

⁴¹ And why beholdest thou the mote that is in thy brother's eye, but perceivest not the beam that is in thine own eye?

⁴² Either how canst thou say to thy brother, Brother, let me pull out the mote that is in thine eye, when thou thyself beholdest not the beam that is in thine own eye? Thou hypocrite, cast out first the beam out of thine own eye, and then shalt thou see clearly to pull out the mote that is in thy brother's eye.

⁴³ For a good tree bringeth not forth corrupt fruit; neither doth a corrupt tree bring forth good fruit.

⁴⁴ For every tree is known by his own fruit. For of thorns men do not gather figs, nor of a bramble bush gather they grapes.

⁴⁵ A good man out of the good treasure of his heart bringeth forth that which is good; and an evil man out of the evil treasure of his heart bringeth forth that which is evil: for of the abundance of the heart his mouth speaketh.

⁴⁶ And why call ye me, Lord, Lord, and do not the things which I say?

⁴⁷ Whosoever cometh to me, and heareth my sayings, and doeth them, I will shew you to whom he is like:

⁴⁸ He is like a man which built an house, and digged deep, and

laid the foundation on a rock: and when the flood arose, the stream beat vehemently upon that house, and could not shake it: for it was founded upon a rock.

⁴⁹ But he that heareth, and doeth not, is like a man that without a foundation built an house upon the earth; against which the stream did beat vehemently, and immediately it fell; and the ruin of that house was great.

Tiziano Vecellio, 1488–1576;
Resurrection of Christ, detail from
the Averoldi Altarpiece, 1510–1520;
Collegiate Church of Saints Nazario
and Celso, Brescia, Italy.

THE PASSION

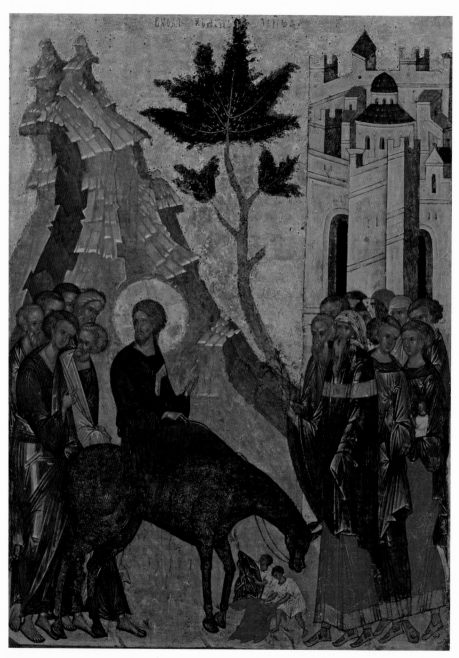

Russian icon, 15th century; *The Entry of Christ into Jerusalem*, 1497; Kirillo–Belozersky Monastery, Russia

ENTRY INTO JERUSALEM

Matthew 21:1–11

nd when they drew nigh unto Jerusalem, and were come to Bethphage, unto the mount of Olives, then sent Jesus two disciples,

² Saying unto them, Go into the village over against you, and straightway ye shall find an ass tied, and a colt with her: loose *them*, and bring *them* unto me.

³ And if any *man* say ought unto you, ye shall say, The Lord hath need of them; and straightway he will send them.

⁴ All this was done, that it might be fulfilled which was spoken by the prophet, saying,

⁵ Tell ye the daughter of Sion, Behold, thy King cometh unto thee, meek, and sitting upon an ass, and a colt the foal of an ass.

⁶ And the disciples went, and did as Jesus commanded them,

⁷ And brought the ass, and the colt, and put on them their clothes, and they set *him* thereon.

⁸ And a very great multitude spread their garments in the way; others cut down branches from the trees, and strawed *them* in the way.

⁹ And the multitudes that went before, and that followed, cried, saying, Hosanna to the Son of David: Blessed *is* he that cometh in the name of the Lord; Hosanna in the highest.

¹⁰ And when he was come into Jerusalem, all the city was moved, saying, Who is this?

¹¹ And the multitude said, This is Jesus the prophet of Nazareth of Galilee.

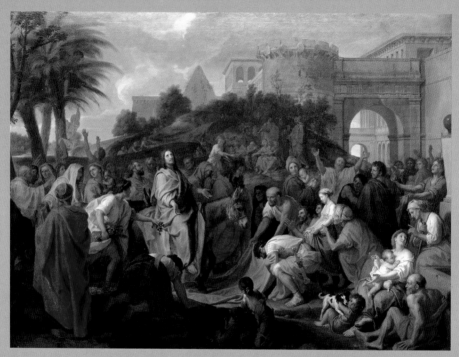

Charles Le Brun, 1619–1690; *Entry of Christ into Jerusalem*, 17th century; Art And Industry Museum, Saint–Étienne, France

Mark 11:1–10

nd when they came nigh to Jerusalem, unto Bethphage and Bethany, at the mount of Olives, he sendeth forth two of his disciples,

2 And saith unto them, Go your way into the village over against you: and as soon as ye be entered into it, ye shall find a colt tied, whereon never man sat; loose him, and bring *him*.

3 And if any man say unto you, Why do ye this? say ye that the Lord hath need of him; and straightway he will send him hither.

4 And they went their way, and found the colt tied by the door without in a place where two ways met; and they loose him.

5 And certain of them that stood there said unto them, What do ye, loosing the colt?

6 And they said unto them even as Jesus had commanded: and they let them go.

7 And they brought the colt to Jesus, and cast their garments on him; and he sat upon him.

8 And many spread their garments in the way: and others cut down branches off the trees, and strawed *them* in the way.

9 And they that went before, and they that followed, cried, saying, Hosanna; Blessed *is* he that cometh in the name of the Lord:

10 Blessed *be* the kingdom of our father David, that cometh in the name of the Lord: Hosanna in the highest.

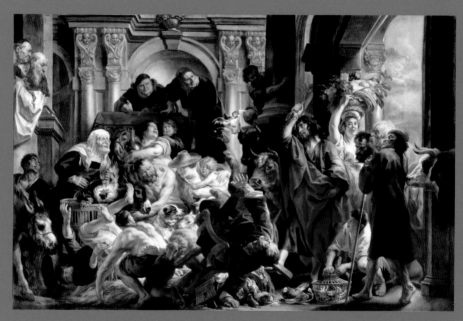

Jacob Jordeaens, 1593–1678; *Christ Driving the Merchants from the Temple*, ca. 1650; Louvre, Paris

DRIVING MERCHANTS FROM THE TEMPLE

John 2:12–17

fter this he went down to Capernaum, he, and his mother, and his brethren, and his disciples: and they continued there not many days.

13 And the Jews' passover was at hand, and Jesus went up to Jerusalem,

14 And found in the temple those that sold oxen and sheep and doves, and the changers of money sitting:

15 And when he had made a scourge of small cords, he drove them all out of the temple, and the sheep, and the oxen; and poured out the changers' money, and overthrew the tables;

16 And said unto them that sold doves, Take these things hence; make not my Father's house an house of merchandise.

17 And his disciples remembered that it was written, The zeal of thine house hath eaten me up.

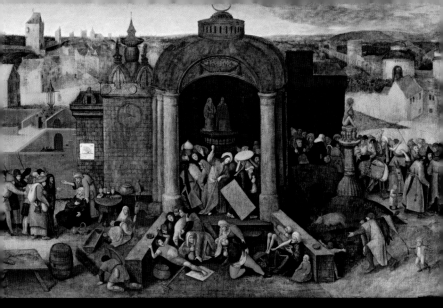

Pieter Bruegel the Elder (attributed to), ca. 1525–1569; *Christ Driving the Traders from the Temple*, after 1569; Statens

Mark 11:15–19

nd they come to Jerusalem: and Jesus went into the temple, and began to cast out them that sold and bought in the temple, and overthrew the tables of the moneychangers, and the seats of them that sold doves;

¹⁶ And would not suffer that any man should carry *any* vessel through the temple.

¹⁷ And he taught, saying unto them, Is it not written, My house shall be called of all nations the house of prayer? but ye have made it a den of thieves.

¹⁸ And the scribes and chief priests heard *it*, and sought how they might destroy him: for they feared him, because all the people was astonished at his doctrine.

¹⁹ And when even was come, he went out of the city.

THE LAST
SUPPER

Luke 22:7–38

hen came the day of unleavened bread, when the passover must be killed.

⁸ And he sent Peter and John, saying, Go and prepare us the passover, that we may eat.

⁹ And they said unto him, Where wilt thou that we prepare?

¹⁰ And he said unto them, Behold, when ye are entered into the city, there shall a man meet you, bearing a pitcher of water; follow him into the house where he entereth in.

¹¹ And ye shall say unto the goodman of the house, The Master saith unto thee, Where is the guestchamber, where I shall eat the passover with my disciples?

¹² And he shall shew you a large upper room furnished: there make ready.

¹³ And they went, and found as he had said unto them: and they made ready the passover.

¹⁴ And when the hour was come, he sat down, and the twelve apostles with him.

¹⁵ And he said unto them, With desire I have desired to eat this passover with you before I suffer:

¹⁶ For I say unto you, I will not any more eat thereof, until it be fulfilled in the kingdom of God.

¹⁷ And he took the cup, and gave thanks, and said, Take this, and divide *it* among yourselves:

¹⁸ For I say unto you, I will not drink of the fruit of the vine, until the kingdom of God shall come.

¹⁹ And he took bread, and gave thanks, and brake *it*, and gave unto them, saying, This is my body which is given for you: this do in remembrance of me.

²⁰ Likewise also the cup after supper, saying, This cup *is* the new testament in my blood, which is shed for you.

²¹ But, behold, the hand of

him that betrayeth me *is* with me on the table.

²² And truly the Son of man goeth, as it was determined: but woe unto that man by whom he is betrayed!

²³ And they began to enquire among themselves, which of them it was that should do this thing.

²⁴ And there was also a strife among them, which of them should be accounted the greatest.

²⁵ And he said unto them, The kings of the Gentiles exercise lordship over them; and they that exercise authority upon them are called benefactors.

²⁶ But ye *shall* not *be* so: but he that is greatest among you, let him be as the younger; and he that is chief, as he that doth serve.

²⁷ For whether *is* greater, he that sitteth at meat, or he that serveth? *is* not he that sitteth at meat? but I am among you as he that serveth.

²⁸ Ye are they which have continued with me in my temptations.

²⁹ And I appoint unto you a kingdom, as my Father hath appointed unto me;

³⁰ That ye may eat and drink at my table in my kingdom, and sit on thrones judging the twelve tribes of Israel.

³¹ And the Lord said, Simon, Simon, behold, Satan hath desired *to have* you, that he may sift *you* as wheat:

³² But I have prayed for thee, that thy faith fail not: and when thou art converted, strengthen thy brethren.

³³ And he said unto him, Lord, I am ready to go with thee, both into prison, and to death.

³⁴ And he said, I tell thee, Peter, the cock shall not crow this day, before that thou shalt thrice deny that thou knowest me.

³⁵ And he said unto them, When I sent you without purse, and scrip, and shoes, lacked ye any thing? And they said, Nothing.

³⁶ Then said he unto them, But now, he that hath a purse, let him take *it*, and likewise *his* scrip: and he that hath no sword, let him sell his garment, and buy one.

³⁷ For I say unto you, that this that is written must yet be accomplished in me, And he was reckoned among the transgressors: for the things concerning me have an end.

³⁸ And they said, Lord, behold, here *are* two swords. And he said unto them, It is enough.

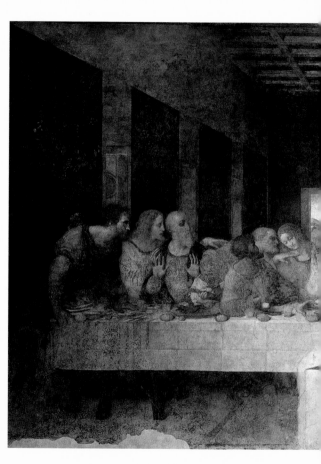

Leonardo da Vinci, 1452–
1519; *The Last Supper*,
1494–1498; Santa Maria
delle Grazie, Milan

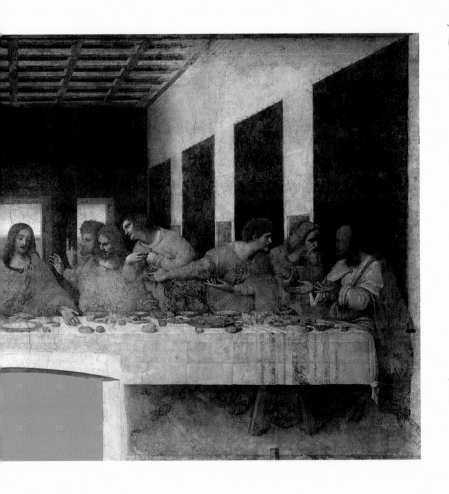

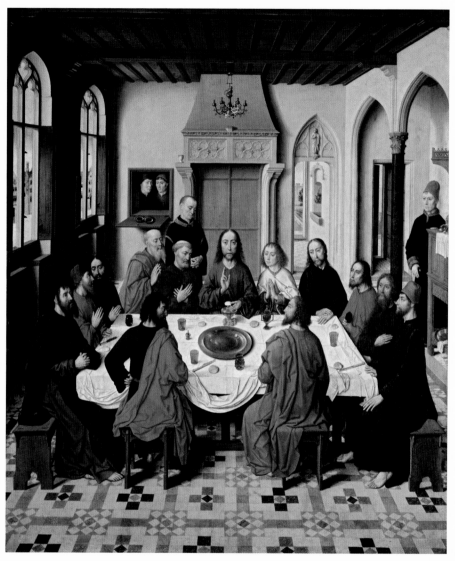

Dieric Bouts the Elder, ca. 1415–1475; *The Last Supper*, 1464–67; Sint–Pieterskerk, Leuven, Belgium

Matthew 26:17–29

ow the first *day* of
the *feast of* unleavened bread the disciples came to
Jesus, saying unto him, Where
wilt thou that we prepare for
thee to eat the passover?

¹⁸ And he said, Go into the city
to such a man, and say unto him,
The Master saith, My time is at
hand; I will keep the passover at
thy house with my disciples.

¹⁹ And the disciples did as
Jesus had appointed them; and
they made ready the passover.

²⁰ Now when the even was
come, he sat down with the
twelve.

²¹ And as they did eat, he said,
Verily I say unto you, that one
of you shall betray me.

²² And they were exceeding
sorrowful, and began every one
of them to say unto him, Lord,
is it I?

²³ And he answered and said,
He that dippeth *his* hand with
me in the dish, the same shall
betray me.

²⁴ The Son of man goeth as it
is written of him: but woe unto
that man by whom the Son of
man is betrayed! it had been
good for that man if he had not
been born.

²⁵ Then Judas, which betrayed
him, answered and said, Master,
is it I? He said unto him, Thou
hast said.

²⁶ And as they were eating,
Jesus took bread, and blessed *it*,
and brake *it*, and gave *it* to the
disciples, and said, Take, eat;
this is my body.

²⁷ And he took the cup, and
gave thanks, and gave *it* to
them, saying, Drink ye all of it;

²⁸ For this is my blood of the
new testament, which is shed
for many for the remission of
sins.

²⁹ But I say unto you, I will
not drink henceforth of this
fruit of the vine, until that day
when I drink it new with you in
my Father's kingdom.

AGONY IN THE GARDEN

Mark 14:26–42

nd when they had sung an hymn, they went out into the mount of Olives.

²⁷ And Jesus saith unto them, All ye shall be offended because of me this night: for it is written, I will smite the shepherd, and the sheep shall be scattered.

²⁸ But after that I am risen, I will go before you into Galilee.

²⁹ But Peter said unto him, Although all shall be offended, yet *will* not I.

³⁰ And Jesus saith unto him, Verily I say unto thee, That this day, *even* in this night, before the cock crow twice, thou shalt deny me thrice.

³¹ But he spake the more vehemently, If I should die with thee, I will not deny thee in any wise. Likewise also said they all.

³² And they came to a place which was named Gethsemane: and he saith to his disciples, Sit ye here, while I shall pray.

³³ And he taketh with him Peter and James and John, and began to be sore amazed, and to be very heavy;

³⁴ And saith unto them, My soul is exceeding sorrowful unto death: tarry ye here, and watch.

³⁵ And he went forward a little, and fell on the ground, and prayed that, if it were possible, the hour might pass from him.

³⁶ And he said, Abba, Father, all things *are* possible unto thee; take away this cup from me: nevertheless not what I will, but what thou wilt.

³⁷ And he cometh, and findeth them sleeping, and saith unto Peter, Simon, sleepest thou? couldest not thou watch one hour?

³⁸ Watch ye and pray, lest ye enter into temptation. The spirit truly *is* ready, but the flesh *is* weak.

³⁹ And again he went away,

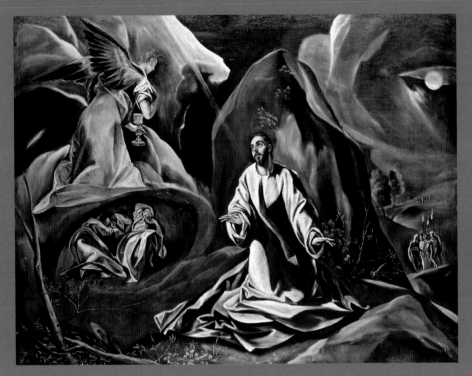

El Greco (Domenikos Theotokopoulos), 1541–1614; *Agony in the Garden*, 1590s; National Gallery, London

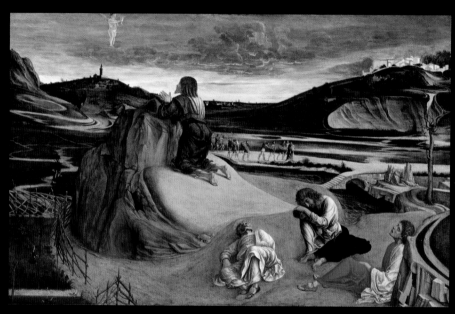

Giovanni Bellini, 1430–1516; *Agony in the Garden*, 1465; National Gallery, London

and prayed, and spake the same words.

⁴⁰ And when he returned, he found them asleep again, (for their eyes were heavy,) neither wist they what to answer him.

⁴¹ And he cometh the third time, and saith unto them, Sleep on now, and take *your* rest: it is enough, the hour is come; behold, the Son of man is betrayed into the hands of sinners.

⁴² Rise up, let us go; lo, he that betrayeth me is at hand.

Luke 22:39–46

nd he came out, and went, as he was wont, to the mount of Olives; and his disciples also followed him.

⁴⁰ And when he was at the place, he said unto them, Pray that ye enter not into temptation.

⁴¹ And he was withdrawn from them about a stone's cast, and kneeled down, and prayed,

⁴² Saying, Father, if thou be willing, remove this cup from me: nevertheless not my will, but thine, be done.

⁴³ And there appeared an angel unto him from heaven, strengthening him.

⁴⁴ And being in an agony he prayed more earnestly: and his sweat was as it were great drops of blood falling down to the ground.

⁴⁵ And when he rose up from prayer, and was come to his disciples, he found them sleeping for sorrow,

⁴⁶ And said unto them, Why sleep ye? rise and pray, lest ye enter into temptation.

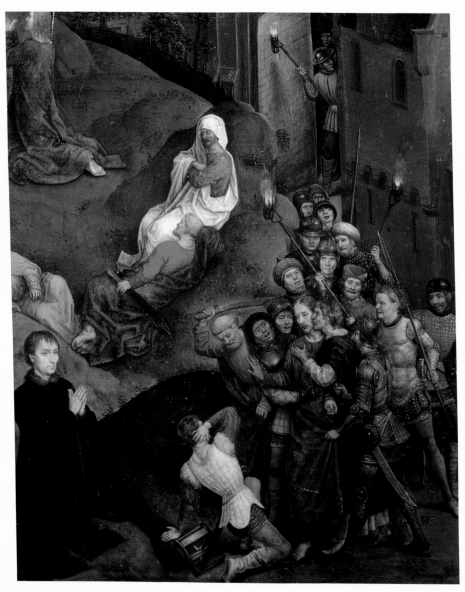

Hans Memling, 1430–1494; Kiss of Judas, detail from *Passion of Christ*, 1471; Galleria Sabauda, Turin

ARREST

John 18:1–13

When Jesus had spoken these words, he went forth with his disciples over the brook Cedron, where was a garden, into the which he entered, and his disciples.

² And Judas also, which betrayed him, knew the place: for Jesus ofttimes resorted thither with his disciples.

³ Judas then, having received a band *of men* and officers from the chief priests and Pharisees, cometh thither with lanterns and torches and weapons.

⁴ Jesus therefore, knowing all things that should come upon him, went forth, and said unto them, Whom seek ye?

⁵ They answered him, Jesus of Nazareth. Jesus saith unto them, I am *he*. And Judas also, which betrayed him, stood with them.

⁶ As soon then as he had said unto them, I am *he*, they went backward, and fell to the ground.

⁷ Then asked he them again, Whom seek ye? And they said, Jesus of Nazareth.

⁸ Jesus answered, I have told you that I am *he*: if therefore ye seek me, let these go their way:

⁹ That the saying might be fulfilled, which he spake, Of them which thou gavest me have I lost none.

¹⁰ Then Simon Peter having a sword drew it, and smote the high priest's servant, and cut off his right ear. The servant's name was Malchus.

¹¹ Then said Jesus unto Peter, Put up thy sword into the sheath: the cup which my Father hath given me, shall I not drink it?

¹² Then the band and the captain and officers of the Jews took Jesus, and bound him,

¹³ And led him away to Annas first; for he was father in law to Caiaphas, which was the high priest that same year.

Matthew 26:47–56

nd while he yet spake, lo, Judas, one of the twelve, came, and with him a great multitude with swords and staves, from the chief priests and elders of the people.

⁴⁸ Now he that betrayed him gave them a sign, saying, Whomsoever I shall kiss, that same is he: hold him fast.

⁴⁹ And forthwith he came to Jesus, and said, Hail, master; and kissed him.

⁵⁰ And Jesus said unto him, Friend, wherefore art thou come? Then came they, and laid hands on Jesus, and took him.

⁵¹ And, behold, one of them which were with Jesus stretched out *his* hand, and drew his sword, and struck a servant of the high priest's, and smote off his ear.

⁵² Then said Jesus unto him, Put up again thy sword into his place: for all they that take the sword shall perish with the sword.

⁵³ Thinkest thou that I cannot now pray to my Father, and he shall presently give me more than twelve legions of angels?

⁵⁴ But how then shall the scriptures be fulfilled, that thus it must be?

⁵⁵ In that same hour said Jesus to the multitudes, Are ye come out as against a thief with swords and staves for to take me? I sat daily with you teaching in the temple, and ye laid no hold on me.

⁵⁶ But all this was done, that the scriptures of the prophets might be fulfilled. Then all the disciples forsook him, and fled.

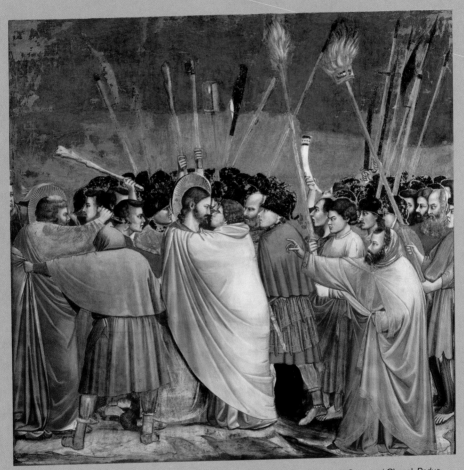

Giotto di Bondone, 1266/7–1337; *Stories of the Passion The Kiss of Judas*, 1303–1306; Scrovegni Chapel, Padua

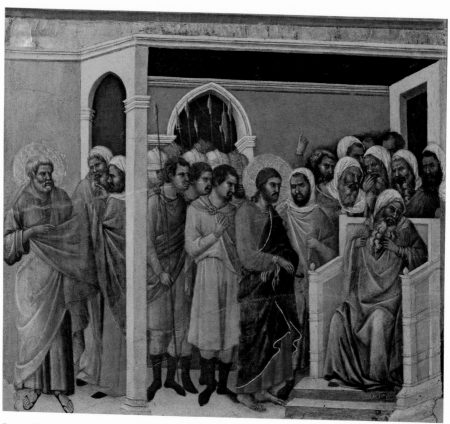

Duccio di Buoninsegna, 1255–1319; *Christ Before Caiaphas*, 1308–1311; Santa Maria Assunta Cathedral, Siena

CHRIST BEFORE CAIAPHAS

Mark 14:53–65

nd they led Jesus away to the high priest: and with him were assembled all the chief priests and the elders and the scribes.

⁵⁴ And Peter followed him afar off, even into the palace of the high priest: and he sat with the servants, and warmed himself at the fire.

⁵⁵ And the chief priests and all the council sought for witness against Jesus to put him to death; and found none.

⁵⁶ For many bare false witness against him, but their witness agreed not together.

⁵⁷ And there arose certain, and bare false witness against him, saying,

⁵⁸ We heard him say, I will destroy this temple that is made with hands, and within three days I will build another made without hands.

⁵⁹ But neither so did their witness agree together.

⁶⁰ And the high priest stood up in the midst, and asked Jesus, saying, Answerest thou nothing? what *is it which* these witness against thee?

⁶¹ But he held his peace, and answered nothing. Again the high priest asked him, and said unto him, Art thou the Christ, the Son of the Blessed?

⁶² And Jesus said, I am: and ye shall see the Son of man sitting on the right hand of power, and coming in the clouds of heaven.

⁶³ Then the high priest rent his clothes, and saith, What need we any further witnesses?

⁶⁴ Ye have heard the blasphemy: what think ye? And they all condemned him to be guilty of death.

⁶⁵ And some began to spit on him, and to cover his face, and to buffet him, and to say unto him, Prophesy: and the servants did strike him with the palms of their hands.

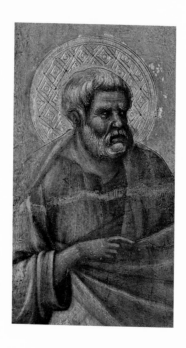

Matthew 26:57–68

nd they that had laid hold on Jesus led *him* away to Caiaphas the high priest, where the scribes and the elders were assembled.

⁵⁸ But Peter followed him afar off unto the high priest's palace, and went in, and sat with the servants, to see the end.

⁵⁹ Now the chief priests, and elders, and all the council, sought false witness against Jesus, to put him to death;

⁶⁰ But found none: yea, though many false witnesses came, *yet* found they none. At the last came two false witnesses,

⁶¹ And said, This *fellow* said, I am able to destroy the temple of God, and to build it in three days.

⁶² And the high priest arose, and said unto him, Answerest thou nothing? what *is it which* these witness against thee?

⁶³ But Jesus held his peace. And the high priest answered and said unto him, I adjure thee by the living God, that thou tell us whether thou be the Christ, the Son of God.

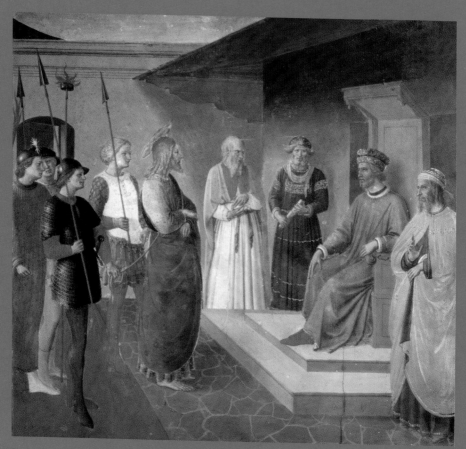

Fra Angelico (Guido di Pietro), 1395–1455; *Jesus Christ Before Caiaphas*, 1445; San Marco Museum, Florence

⁶⁴ Jesus saith unto him, Thou hast said: nevertheless I say unto you, Hereafter shall ye see the Son of man sitting on the right hand of power, and coming in the clouds of heaven.

⁶⁵ Then the high priest rent his clothes, saying, He hath spoken blasphemy; what further need have we of witnesses? behold, now ye have heard his blasphemy.

⁶⁶ What think ye? They answered and said, He is guilty of death.

⁶⁷ Then did they spit in his face, and buffeted him; and others smote *him* with the palms of their hands,

⁶⁸ Saying, Prophesy unto us, thou Christ, Who is he that smote thee?

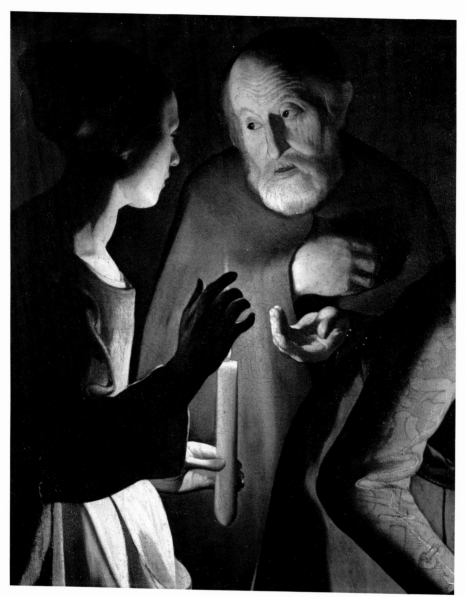

Georges de la Tour, 1593–1652; *The Denial of St. Peter*, 1650; Musée des Beaux Arts, France

DENIAL
OF PETER

Luke 22:54–62

hen took they him, and led *him*, and brought him into the high priest's house. And Peter followed afar off.

⁵⁵ And when they had kindled a fire in the midst of the hall, and were set down together, Peter sat down among them.

⁵⁶ But a certain maid beheld him as he sat by the fire, and earnestly looked upon him, and said, This man was also with him.

⁵⁷ And he denied him, saying, Woman, I know him not.

⁵⁸ And after a little while another saw him, and said, Thou art also of them. And Peter said, Man, I am not.

⁵⁹ And about the space of one hour after another confidently affirmed, saying, Of a truth this *fellow* also was with him: for he is a Galilaean.

⁶⁰ And Peter said, Man, I know not what thou sayest. And immediately, while he yet spake, the cock crew.

⁶¹ And the Lord turned, and looked upon Peter. And Peter remembered the word of the Lord, how he had said unto him, Before the cock crow, thou shalt deny me thrice.

⁶² And Peter went out, and wept bitterly.

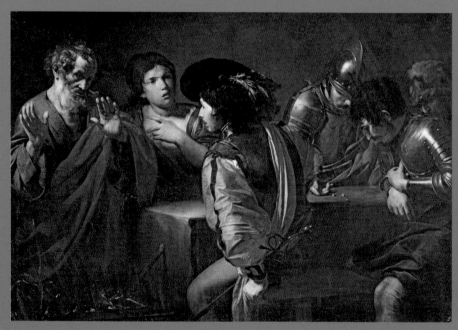

Valentin de Boulogne, 1594–1632; *Denial of St. Peter*, late 16th–17th century; Pushkins Museum of Fine Arts, Moscow

Matthew 14:66–72

 nd as Peter was be-
neath in the palace,
there cometh one of the maids
of the high priest:

⁶⁷ And when she saw Peter
warming himself, she looked
upon him, and said, And thou
also wast with Jesus of Naza-
reth.

⁶⁸ But he denied, saying, I know
not, neither understand I what
thou sayest. And he went out into
the porch; and the cock crew.

⁶⁹ And a maid saw him again,
and began to say to them that
stood by, This is *one* of them.

⁷⁰ And he denied it again. And
a little after, they that stood
by said again to Peter, Surely
thou art *one* of them: for thou
art a Galilaean, and thy speech
agreeth *thereto*.

⁷¹ But he began to curse and to
swear, *saying*, I know not this
man of whom ye speak.

⁷² And the second time the
cock crew. And Peter called to
mind the word that Jesus said
unto him, Before the cock crow
twice, thou shalt deny me thrice.
And when he thought thereon,
he wept.

BEFORE PILATE

John 18:28–40

hen led they Jesus from Caiaphas unto the hall of judgment: and it was early; and they themselves went not into the judgment hall, lest they should be defiled; but that they might eat the passover.

²⁹ Pilate then went out unto them, and said, What accusation bring ye against this man?

³⁰ They answered and said unto him, If he were not a malefactor, we would not have delivered him up unto thee.

³¹ Then said Pilate unto them, Take ye him, and judge him according to your law. The Jews therefore said unto him, It is not lawful for us to put any man to death:

³² That the saying of Jesus might be fulfilled, which he spake, signifying what death he should die.

³³ Then Pilate entered into the judgment hall again, and called Jesus, and said unto him, Art thou the King of the Jews?

³⁴ Jesus answered him, Sayest thou this thing of thyself, or did others tell it thee of me?

³⁵ Pilate answered, Am I a Jew? Thine own nation and the chief priests have delivered thee unto me: what hast thou done?

³⁶ Jesus answered, My kingdom is not of this world: if my kingdom were of this world, then would my servants fight, that I should not be delivered to the Jews: but now is my kingdom not from hence.

³⁷ Pilate therefore said unto him, Art thou a king then? Jesus answered, Thou sayest that I am a king. To this end was I born, and for this cause came I into the world, that I should bear

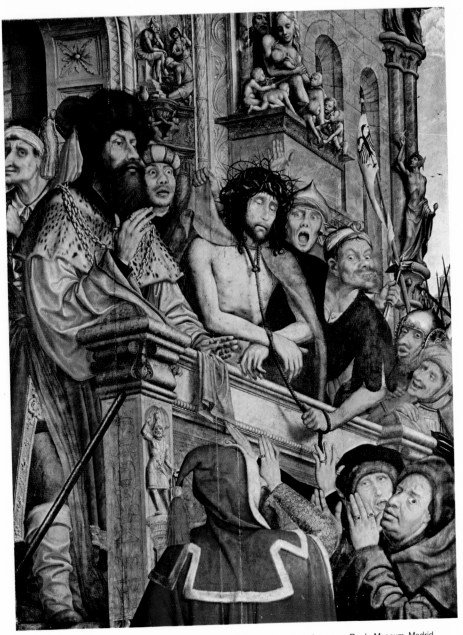

Quentin Metsys, 1466–1530; *Christ Presented to the People*, late 15ᵗʰ–early 16ᵗʰ century; Prado Museum, Madrid

witness unto the truth. Every one that is of the truth heareth my voice.

³⁸ Pilate saith unto him, What is truth? And when he had said this, he went out again unto the Jews, and saith unto them, I find in him no fault *at all*.

³⁹ But ye have a custom, that I should release unto you one at the passover: will ye therefore that I release unto you the King of the Jews?

⁴⁰ Then cried they all again, saying, Not this man, but Barabbas. Now Barabbas was a robber.

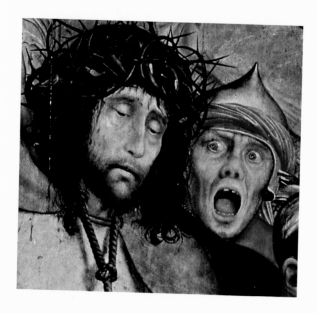

hen the morning was come, all the chief priests and elders of the people took counsel against Jesus to put him to death:

2 And when they had bound him, they led *him* away, and delivered him to Pontius Pilate the governor.

3 Then Judas, which had betrayed him, when he saw that he was condemned, repented himself, and brought again the thirty pieces of silver to the chief priests and elders,

4 Saying, I have sinned in that I have betrayed the innocent blood. And they said, What *is that* to us? see thou *to that.*

5 And he cast down the pieces of silver in the temple, and departed, and went and hanged himself.

6 And the chief priests took the silver pieces, and said, It is not lawful for to put them into the treasury, because it is the price of blood.

7 And they took counsel, and bought with them the potter's field, to bury strangers in.

8 Wherefore that field was called, The field of blood, unto this day.

9 Then was fulfilled that which was spoken by Jeremy the prophet, saying, And they took the thirty pieces of silver, the price of him that was valued, whom they of the children of Israel did value;

10 And gave them for the potter's field, as the Lord appointed me.

11 And Jesus stood before the governor: and the governor asked him, saying, Art thou the King of the Jews? And Jesus said unto him, Thou sayest.

12 And when he was accused of the chief priests and elders, he answered nothing.

13 Then said Pilate unto him, Hearest thou not how many

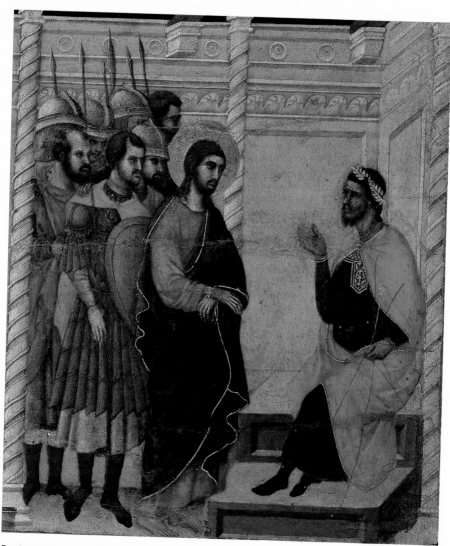

Duccio di Buoninsegna, 1255–1319; *Pilate's First Interrogation of Christ*, 1308–1310; Santa Maria Assunta Cathedral, Siena

things they witness against thee?

14 And he answered him to never a word; insomuch that the governor marvelled greatly.

15 Now at *that* feast the governor was wont to release unto the people a prisoner, whom they would.

16 And they had then a notable prisoner, called Barabbas.

17 Therefore when they were gathered together, Pilate said unto them, Whom will ye that I release unto you? Barabbas, or Jesus which is called Christ?

18 For he knew that for envy they had delivered him.

19 When he was set down on the judgment seat, his wife sent unto him, saying, Have thou nothing to do with that just man: for I have suffered many things this day in a dream because of him.

20 But the chief priests and elders persuaded the multitude that they should ask Barabbas, and destroy Jesus.

21 The governor answered and said unto them, Whether of the twain will ye that I release unto you? They said, Barabbas.

22 Pilate saith unto them, What shall I do then with Jesus which is called Christ? *They* all say unto him, Let him be crucified.

23 And the governor said, Why, what evil hath he done? But they cried out the more, saying, Let him be crucified.

24 When Pilate saw that he could prevail nothing, but *that* rather a tumult was made, he took water, and washed *his* hands before the multitude, saying, I am innocent of the blood of this just person: see ye *to it.*

25 Then answered all the people, and said, His blood *be* on us, and on our children.

26 Then released he Barabbas unto them: and when he had scourged Jesus, he delivered *him* to be crucified.

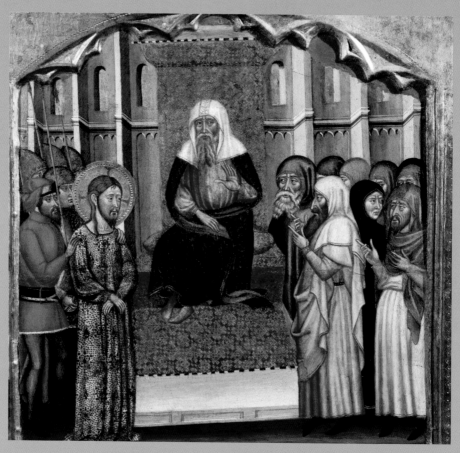

Anonymous Spanish ("Master of Rubio"), 14th century; *Trial of Jesus*, 14th century; Church of Santa Maria, Rubio, Spain

BEFORE HEROD

Luke 23:1–12

nd the whole multitude of them arose, and led him unto Pilate.

2 And they began to accuse him, saying, We found this *fellow* perverting the nation, and forbidding to give tribute to Caesar, saying that he himself is Christ a King.

3 And Pilate asked him, saying, Art thou the King of the Jews? And he answered him and said, Thou sayest *it*.

4 Then said Pilate to the chief priests and *to* the people, I find no fault in this man.

5 And they were the more fierce, saying, He stirreth up the people, teaching throughout all Jewry, beginning from Galilee to this place.

6 When Pilate heard of Galilee, he asked whether the man were a Galilaean.

7 And as soon as he knew that he belonged unto Herod's jurisdiction, he sent him to Herod, who himself also was at Jerusalem at that time.

8 And when Herod saw Jesus, he was exceeding glad: for he was desirous to see him of a long *season*, because he had heard many things of him; and he hoped to have seen some miracle done by him.

9 Then he questioned with him in many words; but he answered him nothing.

10 And the chief priests and scribes stood and vehemently accused him.

11 And Herod with his men of war set him at nought, and mocked *him*, and arrayed him in a gorgeous robe, and sent him again to Pilate.

12 And the same day Pilate and Herod were made friends together: for before they were at enmity between themselves.

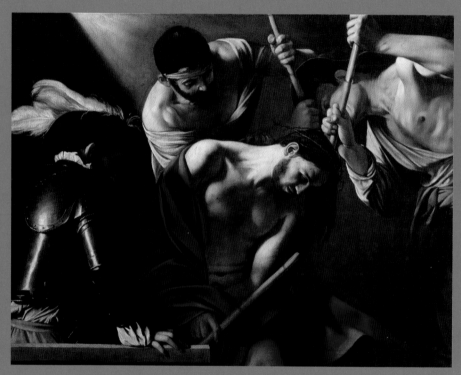

Caravaggio (Michelangelo Merisi), 1571–1610; *The Crowning with Thorns*, ca. 1602/04 or 1607; Kunsthistorisches Museum, Vienna

CHRIST AT THE COLUMN

Mark 15:16–20

 nd the soldiers led him away into the hall, called Praetorium; and they call together the whole band.

¹⁷ And they clothed him with purple, and platted a crown of thorns, and put it about his *head*,

¹⁸ And began to salute him, Hail, King of the Jews!

¹⁹ And they smote him on the head with a reed, and did spit upon him, and bowing *their* knees worshipped him.

²⁰ And when they had mocked him, they took off the purple from him, and put his own clothes on him, and led him out to crucify him.

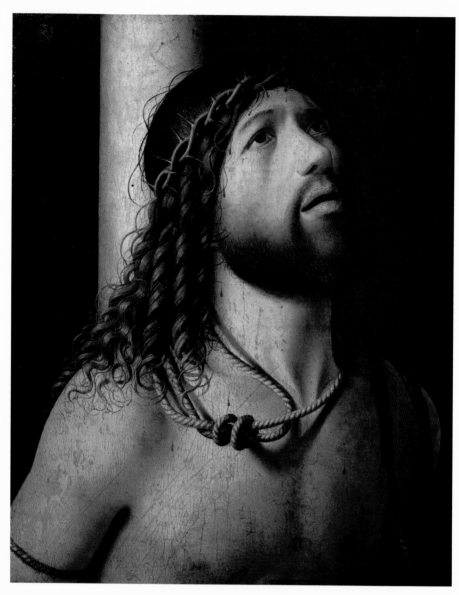

Antonello da Messina, 1430–ca. 1479; *Christ at the Column*, Louvre, Paris

hen the soldiers of the governor took Jesus into the common hall, and gathered unto him the whole band *of soldiers*.

²⁸ And they stripped him, and put on him a scarlet robe.

²⁹ And when they had platted a crown of thorns, they put *it* upon his head, and a reed in his right hand: and they bowed the knee before him, and mocked him, saying, Hail, King of the Jews!

³⁰ And they spit upon him, and took the reed, and smote him on the head.

³¹ And after that they had mocked him, they took the robe off from him, and put his own raiment on him, and led him away to crucify *him*.

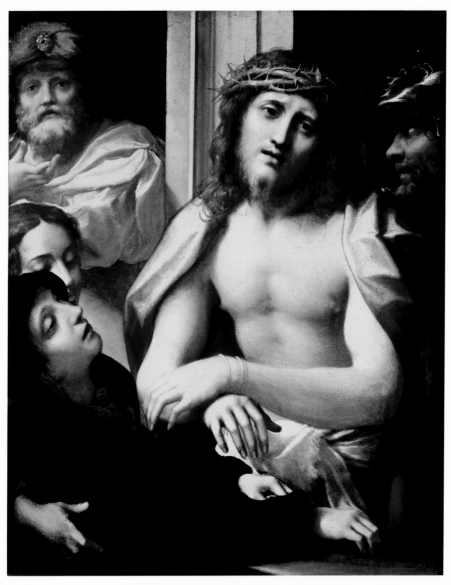

Correggio (Antonio Allegri), 1489–1534; *Christ Presented to the People (Ecce Homo)*, ca. 1526; National Gallery, London

ECCE HOMO

John 18:1–16

hen Pilate therefore took Jesus, and scourged *him*.

² And the soldiers platted a crown of thorns, and put *it* on his head, and they put on him a purple robe,

³ And said, Hail, King of the Jews! and they smote him with their hands.

⁴ Pilate therefore went forth again, and saith unto them, Behold, I bring him forth to you, that ye may know that I find no fault in him.

⁵ Then came Jesus forth, wearing the crown of thorns, and the purple robe. And *Pilate* saith unto them, Behold the man!

⁶ When the chief priests therefore and officers saw him, they cried out, saying, Crucify *him*, crucify *him*. Pilate saith unto them, Take ye him, and crucify *him*: for I find no fault in him.

⁷ The Jews answered him, We have a law, and by our law he ought to die, because he made himself the Son of God.

⁸ When Pilate therefore heard that saying, he was the more afraid;

⁹ And went again into the judgment hall, and saith unto Jesus, Whence art thou? But Jesus gave him no answer.

¹⁰ Then saith Pilate unto him, Speakest thou not unto me? knowest thou not that I have power to crucify thee, and have power to release thee?

¹¹ Jesus answered, Thou couldest have no power *at all* against me, except it were given thee from above: therefore he that delivered me unto thee hath the greater sin.

¹² And from thenceforth Pilate sought to release him: but the Jews cried out, saying, If thou

let this man go, thou art not Caesar's friend: whosoever maketh himself a king speaketh against Caesar.

¹³ When Pilate therefore heard that saying, he brought Jesus forth, and sat down in the judgment seat in a place that is called the Pavement, but in the Hebrew, Gabbatha.

¹⁴ And it was the preparation of the passover, and about the sixth hour: and he saith unto the Jews, Behold your King!

¹⁵ But they cried out, Away with *him*, away with *him*, crucify him. Pilate saith unto them, Shall I crucify your King? The chief priests answered, We have no king but Caesar.

¹⁶ Then delivered he him therefore unto them to be crucified. And they took Jesus, and led *him* away.

ROAD TO CALVARY

Luke 23:26–31

nd as they led him away, they laid hold upon one Simon, a Cyrenian, coming out of the country, and on him they laid the cross, that he might bear *it* after Jesus.

²⁷ And there followed him a great company of people, and of women, which also bewailed and lamented him.

²⁸ But Jesus turning unto them said, Daughters of Jerusalem, weep not for me, but weep for yourselves, and for your children.

²⁹ For, behold, the days are coming, in the which they shall say, Blessed *are* the barren, and the wombs that never bare, and the paps which never gave suck.

³⁰ Then shall they begin to say to the mountains, Fall on us; and to the hills, Cover us.

³¹ For if they do these things in a green tree, what shall be done in the dry?

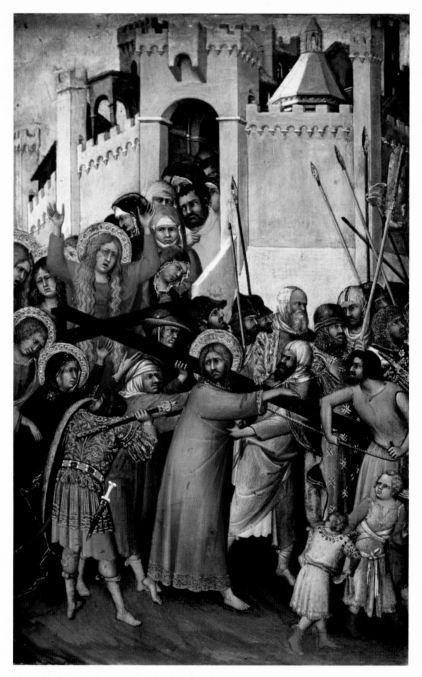

Simone Martini, ca. 1284–1344; *The Carrying of the Cross*, ca. 1335; Louvre, Paris

Mark 15:21–22

nd they compel one Simon a Cyrenian, who passed by, coming out of the country, the father of Alexander and Rufus, to bear his cross.

²² And they bring him unto the place Golgotha, which is, being interpreted, The place of a skull.

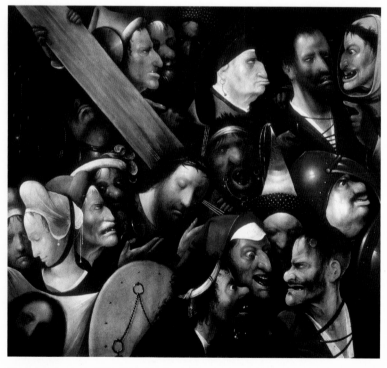

Hieronymus Bosch, ca. 1480–1516; *Carrying the Cross*, ca. 1510–1535; Museum of Fine Arts in Ghent, Belgium

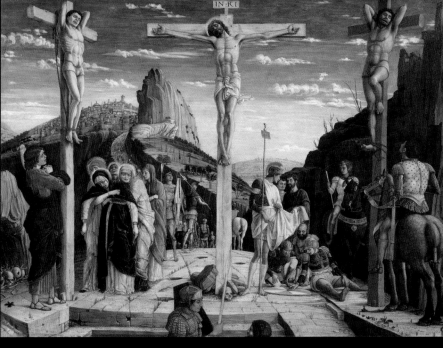

Andrea Mantegna, 1431–1506; *Crucifixion*, 1457–59; Louvre, Paris

CRUCIFIXION

John 19:17–30

And he bearing his cross went forth into a place called *the place* of a skull, which is called in the Hebrew Golgotha:

¹⁸ Where they crucified him, and two other with him, on either side one, and Jesus in the midst.

¹⁹ And Pilate wrote a title, and put *it* on the cross. And the writing was, JESUS OF NAZARETH THE KING OF THE JEWS.

²⁰ This title then read many of the Jews: for the place where Jesus was crucified was nigh to the city: and it was written in Hebrew, *and* Greek, *and* Latin.

²¹ Then said the chief priests of the Jews to Pilate, Write not, The King of the Jews; but that he said, I am King of the Jews.

²² Pilate answered, What I have written I have written.

²³ Then the soldiers, when they had crucified Jesus, took his garments, and made four parts, to every soldier a part; and also *his* coat: now the coat was without seam, woven from the top throughout.

²⁴ They said therefore among themselves, Let us not rend it, but cast lots for it, whose it shall be: that the scripture might be fulfilled, which saith, They parted my raiment among them, and for my vesture they did cast lots. These things therefore the soldiers did.

²⁵ Now there stood by the cross of Jesus his mother, and his mother's sister, Mary the *wife* of Cleophas, and Mary Magdalene.

²⁶ When Jesus therefore saw his mother, and the disciple standing by, whom he loved, he saith unto his mother, Woman, behold thy son!

²⁷ Then saith he to the disciple, Behold thy mother! And from that hour that disciple took her unto his own *home*.

²⁸ After this, Jesus knowing that all things were now accomplished, that the scripture might be fulfilled, saith, I thirst.

²⁹ Now there was set a vessel full of vinegar: and they filled a spunge with vinegar, and put *it* upon hyssop, and put *it* to his mouth.

³⁰ When Jesus therefore had received the vinegar, he said, It is finished: and he bowed his head, and gave up the ghost.

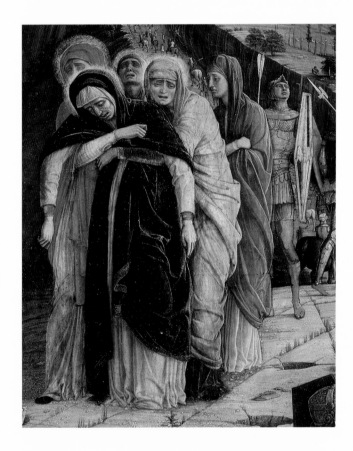

nd when they were come unto a place called Golgotha, that is to say, a place of a skull,

³⁴ They gave him vinegar to drink mingled with gall: and when he had tasted *thereof*, he would not drink.

³⁵ And they crucified him, and parted his garments, casting lots: that it might be fulfilled which was spoken by the prophet, They parted my garments among them, and upon my vesture did they cast lots.

³⁶ And sitting down they watched him there;

³⁷ And set up over his head his accusation written, THIS IS JESUS THE KING OF THE JEWS.

³⁸ Then were there two thieves crucified with him, one on the right hand, and another on the left.

³⁹ And they that passed by reviled him, wagging their heads,

⁴⁰ And saying, Thou that destroyest the temple, and buildest *it* in three days, save thyself. If thou be the Son of God, come down from the cross.

⁴¹ Likewise also the chief priests mocking *him*, with the scribes and elders, said,

⁴² He saved others; himself he cannot save. If he be the King of Israel, let him now come down from the cross, and we will believe him.

⁴³ He trusted in God; let him deliver him now, if he will have him: for he said, I am the Son of God.

⁴⁴ The thieves also, which were crucified with him, cast the same in his teeth.

⁴⁵ Now from the sixth hour there was darkness over all the land unto the ninth hour.

⁴⁶ And about the ninth hour Jesus cried with a loud voice, saying, Eli, Eli, lama sabachthani? that is to say, My God, my God, why hast thou forsaken me?

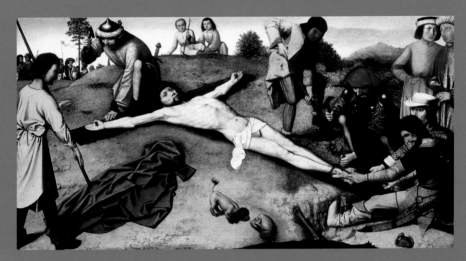

Gerard David, 1460–1523; *Christ Nailed to the Cross*, ca. 1481; National Gallery, London

⁴⁷ Some of them that stood there, when they heard *that*, said, This *man* calleth for Elias.

⁴⁸ And straightway one of them ran, and took a spunge, and filled *it* with vinegar, and put *it* on a reed, and gave him to drink.

⁴⁹ The rest said, Let be, let us see whether Elias will come to save him.

⁵⁰ Jesus, when he had cried again with a loud voice, yielded up the ghost.

⁵¹ And, behold, the veil of the temple was rent in twain from the top to the bottom; and the earth did quake, and the rocks rent;

⁵² And the graves were opened; and many bodies of the saints which slept arose,

⁵³ And came out of the graves after his resurrection, and went into the holy city, and appeared unto many.

⁵⁴ Now when the centurion, and they that were with him, watching Jesus, saw the earth-quake, and those things that were done, they feared greatly, saying, Truly this was the Son of God.

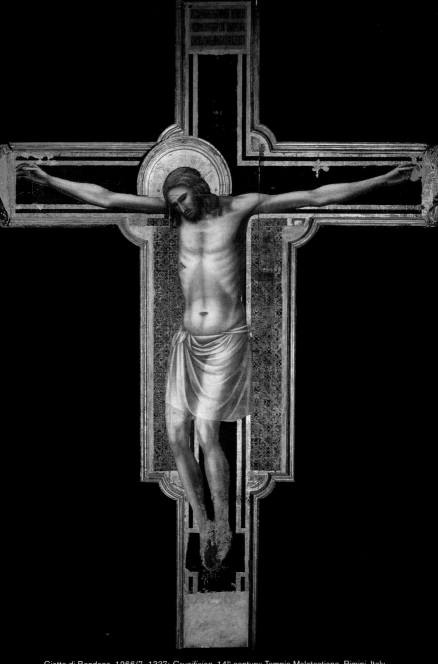

Giotto di Bondone. 1266/7–1337; *Crucifixion*, 14th century; Tempio Malatestiano, Rimini, Italy

nd they bring him unto the place Golgotha, which is, being interpreted, The place of a skull.

²³ And they gave him to drink wine mingled with myrrh: but he received *it* not.

²⁴ And when they had crucified him, they parted his garments, casting lots upon them, what every man should take.

²⁵ And it was the third hour, and they crucified him.

²⁶ And the superscription of his accusation was written over, THE KING OF THE JEWS.

²⁷ And with him they crucify two thieves; the one on his right hand, and the other on his left.

²⁸ And the scripture was fulfilled, which saith, And he was numbered with the transgressors.

²⁹ And they that passed by railed on him, wagging their heads, and saying, Ah, thou that destroyest the temple, and buildest *it* in three days,

³⁰ Save thyself, and come down from the cross.

³¹ Likewise also the chief priests mocking said among themselves with the scribes, He saved others; himself he cannot save.

³² Let Christ the King of Israel descend now from the cross, that we may see and believe. And they that were crucified with him reviled him.

³³ And when the sixth hour was come, there was darkness over the whole land until the ninth hour.

³⁴ And at the ninth hour Jesus cried with a loud voice, saying, Eloi, Eloi, lama sabachthani? which is, being interpreted, My God, my God, why hast thou forsaken me?

³⁵ And some of them that stood by, when they heard *it*, said, Behold, he calleth Elias.

³⁶ And one ran and filled a spunge full of vinegar, and put *it* on a reed, and gave him to drink, saying, Let alone; let us see whether Elias will come to take him down.

³⁷ And Jesus cried with a loud voice, and gave up the ghost.

³⁸ And the veil of the temple was rent in twain from the top to the bottom.

³⁹ And when the centurion, which stood over against him, saw that he so cried out, and gave up the ghost, he said, Truly this man was the Son of God.

nd when they were come to the place, which is called Calvary, there they crucified him, and the malefactors, one on the right hand, and the other on the left.

³⁴ Then said Jesus, Father, forgive them; for they know not what they do. And they parted his raiment, and cast lots.

³⁵ And the people stood beholding. And the rulers also with them derided *him*, saying, He saved others; let him save himself, if he be Christ, the chosen of God.

³⁶ And the soldiers also mocked him, coming to him, and offering him vinegar,

³⁷ And saying, If thou be the king of the Jews, save thyself.

³⁸ And a superscription also was written over him in letters of Greek, and Latin, and Hebrew, THIS IS THE KING OF THE JEWS.

³⁹ And one of the malefactors which were hanged railed on him, saying, If thou be Christ, save thyself and us.

⁴⁰ But the other answering rebuked him, saying, Dost not thou fear God, seeing thou art in the same condemnation?

⁴¹ And we indeed justly; for we receive the due reward of our deeds: but this man hath done nothing amiss.

⁴² And he said unto Jesus, Lord, remember me when thou comest into thy kingdom.

⁴³ And Jesus said unto him, Verily I say unto thee, To day shalt thou be with me in paradise.

⁴⁴ And it was about the sixth hour, and there was a darkness over all the earth until the ninth hour.

⁴⁵ And the sun was darkened, and the veil of the temple was rent in the midst.

⁴⁶ And when Jesus had cried with a loud voice, he said,

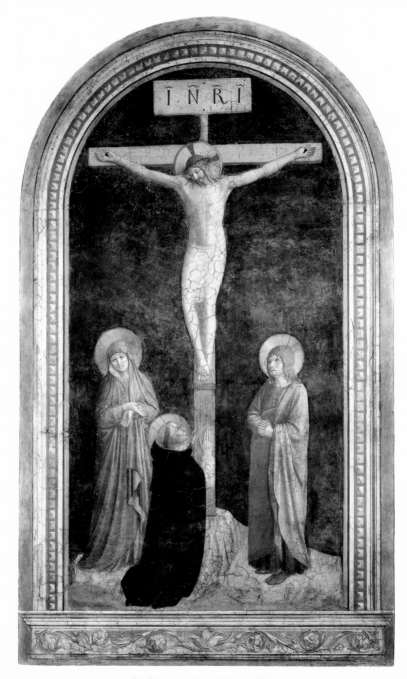

Fra Angelico, ca. 1400–1455; *The Calvary*, 1440–1445; Louvre, Paris

Father, into thy hands I commend my spirit: and having said thus, he gave up the ghost.

⁴⁷ Now when the centurion saw what was done, he glorified God, saying, Certainly this was a righteous man.

⁴⁸ And all the people that came together to that sight, beholding the things which were done, smote their breasts, and returned.

⁴⁹ And all his acquaintance, and the women that followed him from Galilee, stood afar off, beholding these things.

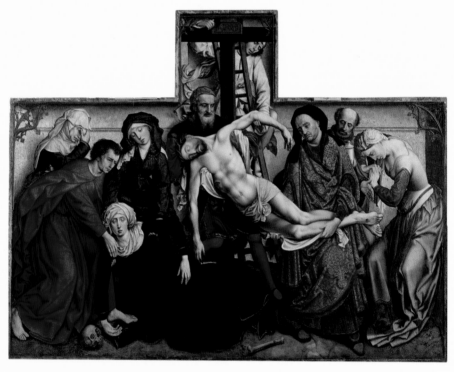

Rogier Van der Weyden, 1400–1464; *The Descent from the Cross*, ca. 1435; Prado Museum, Madrid

DEPOSITION
AND LAMENTATION
John 19:31–38

he Jews therefore, because it was the preparation, that the bodies should not remain upon the cross on the sabbath day, (for that sabbath day was an high day,) besought Pilate that their legs might be broken, and *that* they might be taken away.

³² Then came the soldiers, and brake the legs of the first, and of the other which was crucified with him.

³³ But when they came to Jesus, and saw that he was dead already, they brake not his legs:

³⁴ But one of the soldiers with a spear pierced his side, and forthwith came there out blood and water.

³⁵ And he that saw *it* bare record, and his record is true: and he knoweth that he saith true, that ye might believe.

³⁶ For these things were done, that the scripture should be fulfilled, A bone of him shall not be broken.

³⁷ And again another scripture saith, They shall look on him whom they pierced.

³⁸ And after this Joseph of Arimathaea, being a disciple of Jesus, but secretly for fear of the Jews, besought Pilate that he might take away the body of Jesus: and Pilate gave *him* leave. He came therefore, and took the body of Jesus.

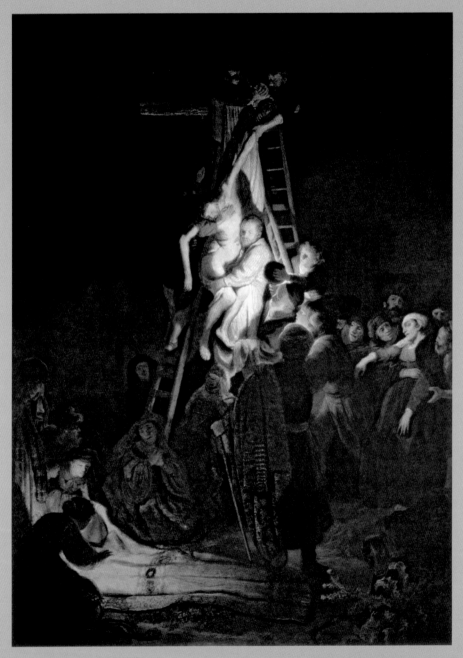

Rembrandt Harmensz van Rijn, 1606–1669; *Descent From the Cross*, 1634; The Hermitage Museum, St Petersburg, Russia

Matthew 27:52–56

 nd the graves were opened; and many bodies of the saints which slept arose,

⁵³ And came out of the graves after his resurrection, and went into the holy city, and appeared unto many.

⁵⁴ Now when the centurion, and they that were with him, watching Jesus, saw the earthquake, and those things that were done, they feared greatly, saying, Truly this was the Son of God.

⁵⁵ And many women were there beholding afar off, which followed Jesus from Galilee, ministering unto him:

⁵⁶ Among which was Mary Magdalene, and Mary the mother of James and Joses, and the mother of Zebedee's children.

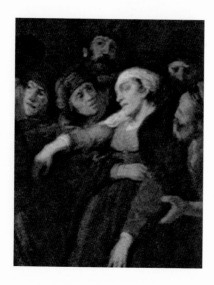

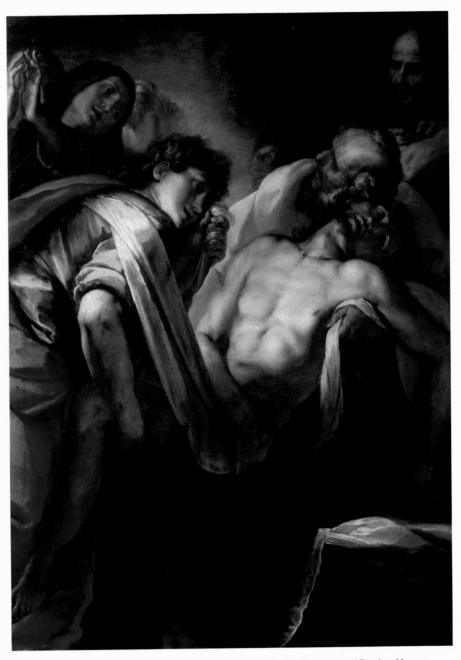

Giulio Cesare Procaccini, 1574–1625; *The Entombment of Christ*, 1620s; Pushkin Museum of Fine Arts, Moscow

THE
ENTOMBMENT

Luke 23:50–56

nd, behold, *there was* a man named Joseph, a counsellor; *and he was* a good man, and a just:

⁵¹ (The same had not consented to the counsel and deed of them;) *he was* of Arimathaea, a city of the Jews: who also himself waited for the kingdom of God.

⁵² This *man* went unto Pilate, and begged the body of Jesus.

⁵³ And he took it down, and wrapped it in linen, and laid it in a sepulchre that was hewn in stone, wherein never man before was laid.

⁵⁴ And that day was the preparation, and the sabbath drew on.

⁵⁵ And the women also, which came with him from Galilee, followed after, and beheld the sepulchre, and how his body was laid.

⁵⁶ And they returned, and prepared spices and ointments; and rested the sabbath day according to the commandment.

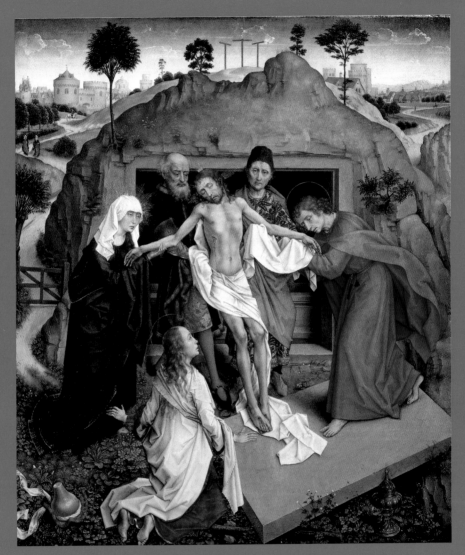

Rogier Van der Weyden, 1399–1464; *Deposition of Christ in the Tomb*, ca. 1450; Uffizi Gallery, Florence

hen the even was come, there came a rich man of Arimathaea, named Joseph, who also himself was Jesus' disciple:

⁵⁸ He went to Pilate, and begged the body of Jesus. Then Pilate commanded the body to be delivered.

⁵⁹ And when Joseph had taken the body, he wrapped it in a clean linen cloth,

⁶⁰ And laid it in his own new tomb, which he had hewn out in the rock: and he rolled a great stone to the door of the sepulchre, and departed.

⁶¹ And there was Mary Magdalene, and the other Mary, sitting over against the sepulchre.

⁶² Now the next day, that followed the day of the preparation, the chief priests and Pharisees came together unto Pilate,

⁶³ Saying, Sir, we remember that that deceiver said, while he was yet alive, After three days I will rise again.

⁶⁴ Command therefore that the sepulchre be made sure until the third day, lest his disciples come by night, and steal him away, and say unto the people, He is risen from the dead: so the last error shall be worse than the first.

⁶⁵ Pilate said unto them, Ye have a watch: go your way, make *it* as sure as ye can.

⁶⁶ So they went, and made the sepulchre sure, sealing the stone, and setting a watch.

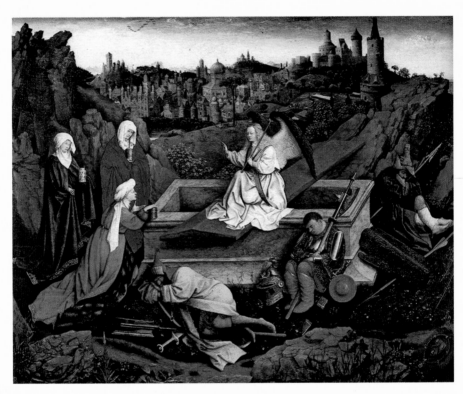

Hubert van Eyck, 1370–1426; *The Three Marys at the Sepulchre*, ca. 1440; Museum Boijmans Van Beuningen, Rotterdam

THE THREE MARYS
AT THE TOMB

Mark 16:1–8

nd when the sabbath was past, Mary Magdalene, and Mary the *mother* of James, and Salome, had bought sweet spices, that they might come and anoint him.

² And very early in the morning the first *day* of the week, they came unto the sepulchre at the rising of the sun.

³ And they said among themselves, Who shall roll us away the stone from the door of the sepulchre?

⁴ And when they looked, they saw that the stone was rolled away: for it was very great.

⁵ And entering into the sepulchre, they saw a young man sitting on the right side, clothed in a long white garment; and they were affrighted.

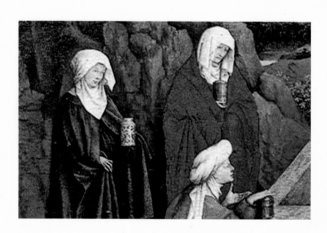

⁶ And he saith unto them, Be not affrighted: Ye seek Jesus of Nazareth, which was crucified: he is risen; he is not here: behold the place where they laid him.

⁷ But go your way, tell his disciples and Peter that he goeth before you into Galilee: there shall ye see him, as he said unto you.

⁸ And they went out quickly, and fled from the sepulchre; for they trembled and were amazed: neither said they any thing to any *man*; for they were afraid.

John 20:1–10

he first *day* of the week cometh Mary Magdalene early, when it was yet dark, unto the sepulchre, and seeth the stone taken away from the sepulchre.

² Then she runneth, and cometh to Simon Peter, and to the other disciple, whom Jesus loved, and saith unto them, They have taken away the Lord out of the sepulchre, and we know not where they have laid him.

³ Peter therefore went forth, and that other disciple, and came to the sepulchre.

⁴ So they ran both together: and the other disciple did out-run Peter, and came first to the sepulchre.

⁵ And he stooping down, *and looking in*, saw the linen clothes lying; yet went he not in.

⁶ Then cometh Simon Peter following him, and went into the sepulchre, and seeth the linen clothes lie,

⁷ And the napkin, that was about his head, not lying with the linen clothes, but wrapped together in a place by itself.

⁸ Then went in also that other disciple, which came first to the sepulchre, and he saw, and believed.

⁹ For as yet they knew not the scripture, that he must rise again from the dead.

¹⁰ Then the disciples went away again unto their own home.

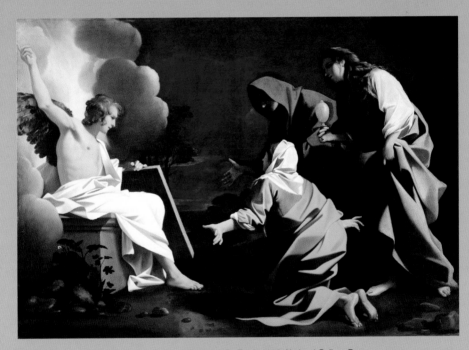

Bartolomeo Schedoni, 1578–1615; *The Three Marys at the Tomb*, 1613; National Gallery, Parma

Matthew 28:1–8

n the end of the sabbath, as it began to dawn toward the first *day* of the week, came Mary Magdalene and the other Mary to see the sepulchre.

² And, behold, there was a great earthquake: for the angel of the Lord descended from heaven, and came and rolled back the stone from the door, and sat upon it.

³ His countenance was like lightning, and his raiment white as snow:

⁴ And for fear of him the keepers did shake, and became as dead *men*.

⁵ And the angel answered and said unto the women, Fear not ye: for I know that ye seek Jesus, which was crucified.

⁶ He is not here: for he is risen, as he said. Come, see the place where the Lord lay.

⁷ And go quickly, and tell his disciples that he is risen from the dead; and, behold, he goeth before you into Galilee; there shall ye see him: lo, I have told you.

⁸ And they departed quickly from the sepulchre with fear and great joy; and did run to bring his disciples word.

NOLI ME TANGERE (TOUCH ME NOT)

John 20:11–18

ut Mary stood without at the sepulchre weeping: and as she wept, she stooped down, *and looked* into the sepulchre,

¹² And seeth two angels in white sitting, the one at the head, and the other at the feet, where the body of Jesus had lain.

¹³ And they say unto her, Woman, why weepest thou? She saith unto them, Because they have taken away my Lord, and I know not where they have laid him.

¹⁴ And when she had thus said, she turned herself back, and saw Jesus standing, and knew not that it was Jesus.

¹⁵ Jesus saith unto her, Woman, why weepest thou? whom seekest thou? She, supposing him to be the gardener, saith unto him, Sir, if thou have borne him hence, tell me where thou hast laid him, and I will take him away.

¹⁶ Jesus saith unto her, Mary. She turned herself, and saith unto him, Rabboni; which is to say, Master.

¹⁷ Jesus saith unto her, Touch me not; for I am not yet ascended to my Father: but go to my brethren, and say unto them, I ascend unto my Father, and your Father; and *to* my God, and your God.

¹⁸ Mary Magdalene came and told the disciples that she had seen the Lord, and *that* he had spoken these things unto her.

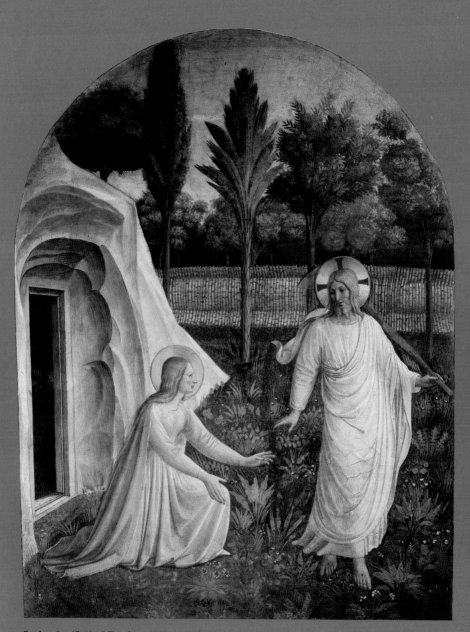

Fra Angelico (Guido di Pietro), ca. 1395–1455; *Noli Me Tangere*, 1438–1466; San Marco Convent, Florence

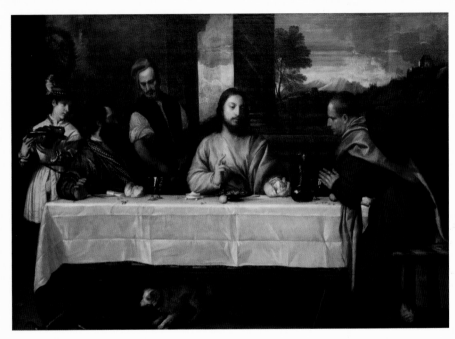

Titian (Tiziano Vecellio), 1485–1576; *The Pilgrims of Emmaus*, 1530; Louvre, Paris

THE SUPPER
AT EMMAUS

Luke 24:10–53

t was Mary Magdalene, and Joanna, and Mary *the mother* of James, and other *women that were* with them, which told these things unto the apostles.

¹¹ And their words seemed to them as idle tales, and they believed them not.

¹² Then arose Peter, and ran unto the sepulchre; and stooping down, he beheld the linen clothes laid by themselves, and departed, wondering in himself at that which was come to pass.

¹³ And, behold, two of them went that same day to a village called Emmaus, which was from Jerusalem *about* threescore furlongs.

¹⁴ And they talked together of all these things which had happened.

¹⁵ And it came to pass, that, while they communed *together* and reasoned, Jesus himself drew near, and went with them.

¹⁶ But their eyes were holden that they should not know him.

¹⁷ And he said unto them, What manner of communications *are* these that ye have one to another, as ye walk, and are sad?

¹⁸ And the one of them, whose name was Cleopas, answering said unto him, Art thou only a stranger in Jerusalem, and hast not known the things which are come to pass there in these days?

¹⁹ And he said unto them, What things? And they said unto him, Concerning Jesus of Nazareth, which was a prophet mighty in deed and word before God and all the people:

²⁰ And how the chief priests and our rulers delivered him

to be condemned to death, and have crucified him.

²¹ But we trusted that it had been he which should have redeemed Israel: and beside all this, to day is the third day since these things were done.

²² Yea, and certain women also of our company made us astonished, which were early at the sepulchre;

²³ And when they found not his body, they came, saying, that they had also seen a vision of angels, which said that he was alive.

²⁴ And certain of them which were with us went to the sepulchre, and found *it* even so as the women had said: but him they saw not.

²⁵ Then he said unto them, O fools, and slow of heart to believe all that the prophets have spoken:

²⁶ Ought not Christ to have suffered these things, and to enter into his glory?

²⁷ And beginning at Moses and all the prophets, he expounded unto them in all the scriptures the things concerning himself.

²⁸ And they drew nigh unto the village, whither they went: and he made as though he would have gone further.

²⁹ But they constrained him, saying, Abide with us: for it is toward evening, and the day is far spent. And he went in to tarry with them.

³⁰ And it came to pass, as he sat at meat with them, he took bread, and blessed *it*, and brake, and gave to them.

³¹ And their eyes were opened, and they knew him; and he vanished out of their sight.

³² And they said one to another, Did not our heart burn within us, while he talked with us by the way, and while he opened to us the scriptures?

³³ And they rose up the same hour, and returned to Jerusalem, and found the eleven gathered together, and them that were with them,

³⁴ Saying, The Lord is risen indeed, and hath appeared to Simon.

³⁵ And they told what things *were done* in the way, and how he was known of them in breaking of bread.

³⁶ And as they thus spake, Jesus himself stood in the midst of them, and saith unto them,

Peace *be* unto you.

37 But they were terrified and affrighted, and supposed that they had seen a spirit.

38 And he said unto them, Why are ye troubled? and why do thoughts arise in your hearts?

39 Behold my hands and my feet, that it is I myself: handle me, and see; for a spirit hath not flesh and bones, as ye see me have.

40 And when he had thus spoken, he shewed them *his* hands and *his* feet.

41 And while they yet believed not for joy, and wondered, he said unto them, Have ye here any meat?

42 And they gave him a piece of a broiled fish, and of an honeycomb.

43 And he took *it*, and did eat before them.

44 And he said unto them, These *are* the words which I spake unto you, while I was yet with you, that all things must be fulfilled, which were written in the law of Moses, and *in* the prophets, and *in* the psalms, concerning me.

45 Then opened he their understanding, that they might understand the scriptures,

46 And said unto them, Thus it is written, and thus it behoved Christ to suffer, and to rise from the dead the third day:

47 And that repentance and remission of sins should be

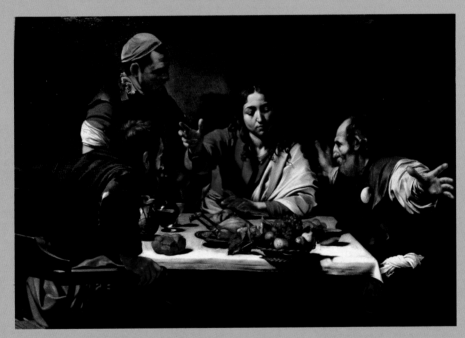

Caravaggio (Michelangelo Merisi), 1571–1610; *Supper at Emmaus*, 1601; National Gallery, London

preached in his name among all nations, beginning at Jerusalem.

⁴⁸ And ye are witnesses of these things.

⁴⁹ And, behold, I send the promise of my Father upon you: but tarry ye in the city of Jerusalem, until ye be endued with power from on high.

⁵⁰ And he led them out as far as to Bethany, and he lifted up his hands, and blessed them.

⁵¹ And it came to pass, while he blessed them, he was parted from them, and carried up into heaven.

⁵² And they worshipped him, and returned to Jerusalem with great joy:

⁵³ And were continually in the temple, praising and blessing God. Amen.

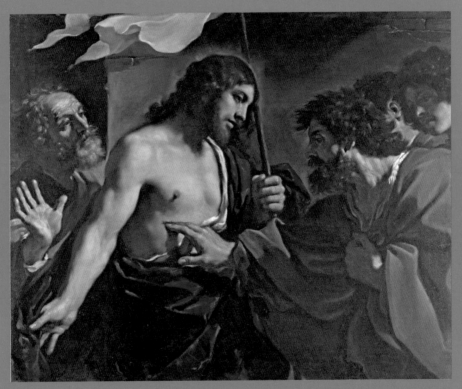

Guercino (Giovanni Francesco Barbieri), 1591–1666; *The Incredulity of Saint Thomas*, 1621; National Gallery, London

INCREDULITY OF ST. THOMAS

John 20:18–31

ary Magdalene came and told the disciples that she had seen the Lord, and *that* he had spoken these things unto her.

¹⁹ Then the same day at evening, being the first *day* of the week, when the doors were shut where the disciples were assembled for fear of the Jews, came Jesus and stood in the midst, and saith unto them, Peace *be* unto you.

²⁰ And when he had so said, he shewed unto them *his* hands and his side. Then were the disciples glad, when they saw the Lord.

²¹ Then said Jesus to them again, Peace *be* unto you: as *my* Father hath sent me, even so send I you.

²² And when he had said this, he breathed on *them*, and saith unto them, Receive ye the Holy Ghost:

²³ Whose soever sins ye remit, they are remitted unto them; *and* whose soever *sins* ye retain, they are retained.

²⁴ But Thomas, one of the twelve, called Didymus, was not with them when Jesus came.

²⁵ The other disciples therefore said unto him, We have seen the Lord. But he said unto them, Except I shall see in his hands the print of the nails, and put my finger into the print of the nails, and thrust my hand into his side, I will not believe.

²⁶ And after eight days again his disciples were within, and Thomas with them: *then* came Jesus, the doors being shut, and stood in the midst, and said, Peace *be* unto you.

²⁷ Then saith he to Thomas, Reach hither thy finger, and

behold my hands; and reach hither thy hand, and thrust *it* into my side: and be not faithless, but believing.

²⁸ And Thomas answered and said unto him, My Lord and my God.

²⁹ Jesus saith unto him, Thomas, because thou hast seen me, thou hast believed: blessed *are* they that have not seen, and *yet* have believed.

³⁰ And many other signs truly did Jesus in the presence of his disciples, which are not written in this book:

³¹ But these are written, that ye might believe that Jesus is the Christ, the Son of God; and that believing ye might have life through his name.

THE ASCENSION

Matthew 28:1–20

n the end of the sabbath, as it began to dawn toward the first *day* of the week, came Mary Magdalene and the other Mary to see the sepulchre.

² And, behold, there was a great earthquake: for the angel of the Lord descended from heaven, and came and rolled back the stone from the door, and sat upon it.

³ His countenance was like lightning, and his raiment white as snow:

⁴ And for fear of him the keepers did shake, and became as dead *men*.

⁵ And the angel answered and said unto the women, Fear not ye: for I know that ye seek Jesus, which was crucified.

⁶ He is not here: for he is risen, as he said. Come, see the place where the Lord lay.

⁷ And go quickly, and tell his disciples that he is risen from the dead; and, behold, he goeth before you into Galilee; there shall ye see him: lo, I have told you.

⁸ And they departed quickly from the sepulchre with fear and great joy; and did run to bring his disciples word.

⁹ And as they went to tell his disciples, behold, Jesus met them, saying, All hail. And they came and held him by the feet, and worshipped him.

¹⁰ Then said Jesus unto them, Be not afraid: go tell my brethren that they go into Galilee, and there shall they see me.

¹¹ Now when they were going, behold, some of the watch

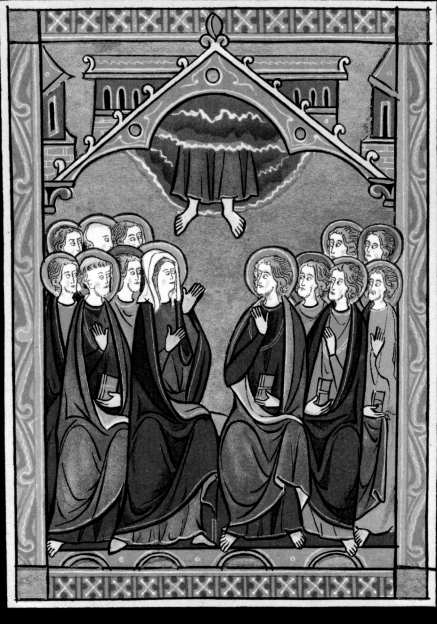

Anonymous English (London Psalter), 13th century; *The Ascension*, 1250–1260; British Museum, London

came into the city, and shewed unto the chief priests all the things that were done.

¹² And when they were assembled with the elders, and had taken counsel, they gave large money unto the soldiers,

¹³ Saying, Say ye, His disciples came by night, and stole him *away* while we slept.

¹⁴ And if this come to the governor's ears, we will persuade him, and secure you.

¹⁵ So they took the money, and did as they were taught: and this saying is commonly reported among the Jews until this day.

¹⁶ Then the eleven disciples went away into Galilee, into a mountain where Jesus had appointed them.

¹⁷ And when they saw him, they worshipped him: but some doubted.

¹⁸ And Jesus came and spake unto them, saying, All power is given unto me in heaven and in earth.

¹⁹ Go ye therefore, and teach all nations, baptizing them in the name of the Father, and of the Son, and of the Holy Ghost:

²⁰ Teaching them to observe all things whatsoever I have commanded you: and, lo, I am with you alway, *even* unto the end of the world. Amen.

nd as they thus spake, Jesus himself stood in the midst of them, and saith unto them, Peace *be* unto you.

³⁷ But they were terrified and affrighted, and supposed that they had seen a spirit.

³⁸ And he said unto them, Why are ye troubled? and why do thoughts arise in your hearts?

³⁹ Behold my hands and my feet, that it is I myself: handle me, and see; for a spirit hath not flesh and bones, as ye see me have.

⁴⁰ And when he had thus spoken, he shewed them *his* hands and *his* feet.

⁴¹ And while they yet believed not for joy, and wondered, he said unto them, Have ye here any meat?

⁴² And they gave him a piece of a broiled fish, and of an honeycomb.

⁴³ And he took *it*, and did eat before them.

⁴⁴ And he said unto them, These *are* the words which I spake unto you, while I was yet with you, that all things must be fulfilled, which were written in the law of Moses, and *in* the prophets, and *in* the psalms, concerning me.

⁴⁵ Then opened he their understanding, that they might understand the scriptures,

⁴⁶ And said unto them, Thus it is written, and thus it behoved Christ to suffer, and to rise from the dead the third day:

⁴⁷ And that repentance and remission of sins should be preached in his name among all nations, beginning at Jerusalem.

⁴⁸ And ye are witnesses of these things.

⁴⁹ And, behold, I send the promise of my Father upon you: but tarry ye in the city of Jerusalem, until ye be endued

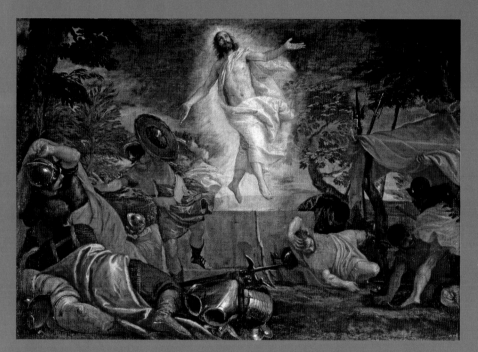

Paolo Veronese, 1528–1588; *The Ascension of Christ*, ca. 1580; Pushkin Museum of Fine Arts, Moscow

with power from on high.

⁵⁰ And he led them out as far as to Bethany, and he lifted up his hands, and blessed them.

⁵¹ And it came to pass, while he blessed them, he was parted from them, and carried up into heaven.

⁵² And they worshipped him, and returned to Jerusalem with great joy:

⁵³ And were continually in the temple, praising and blessing God. Amen.

INDEX OF ARTISTS

INDEX OF PAINTINGS